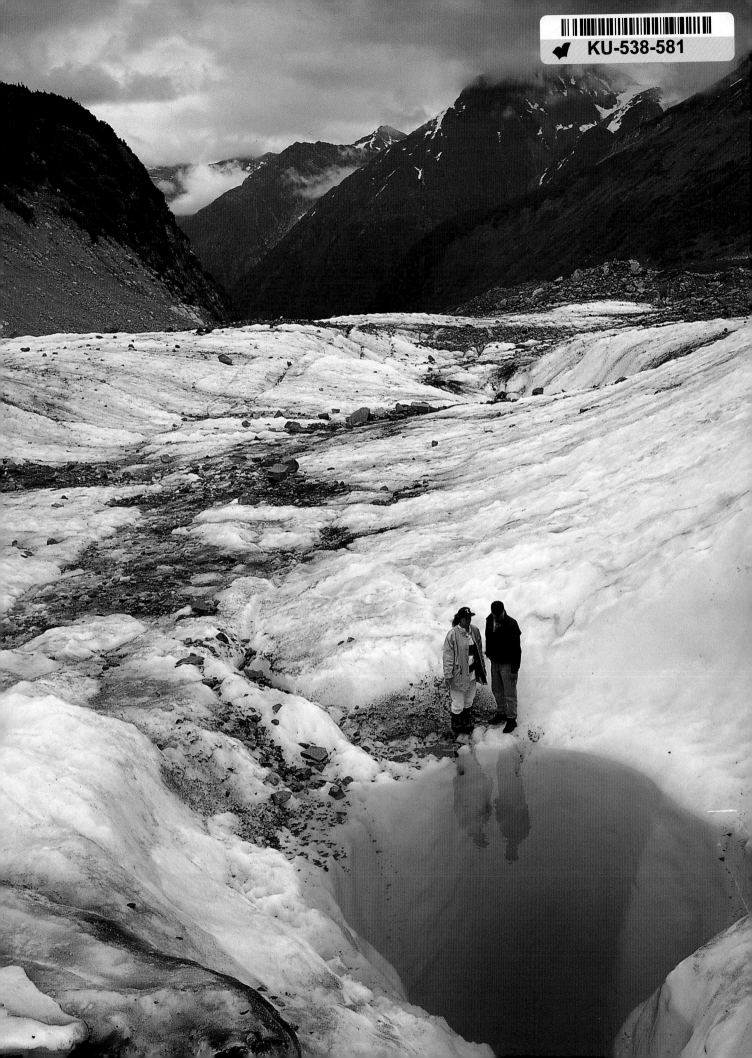

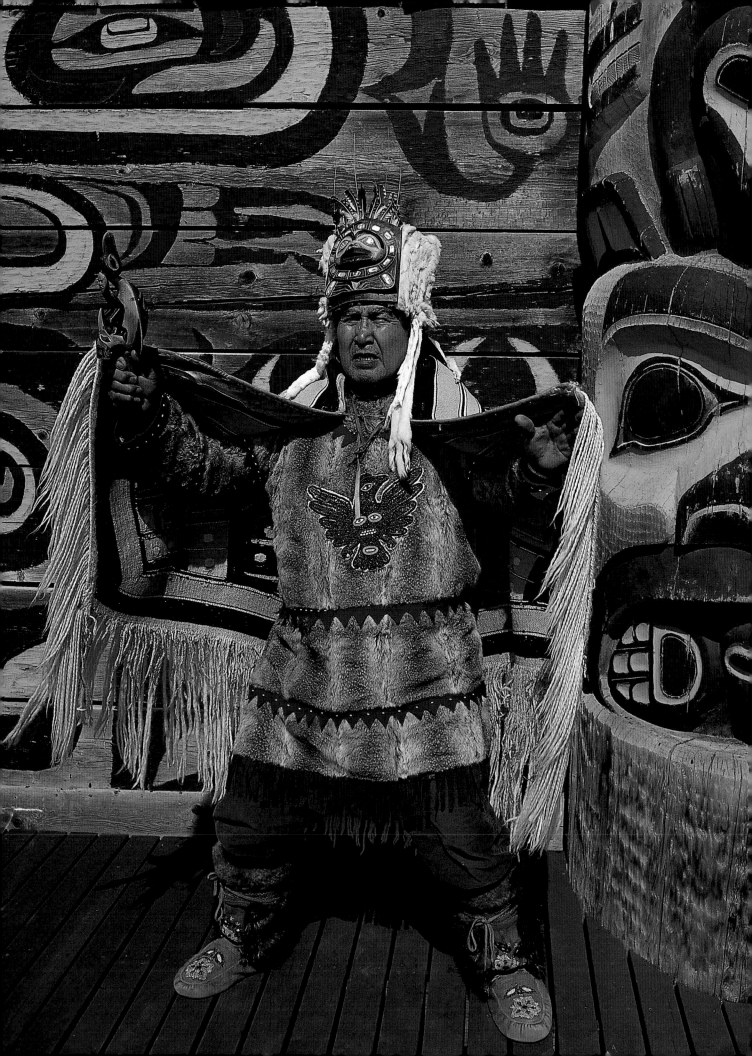

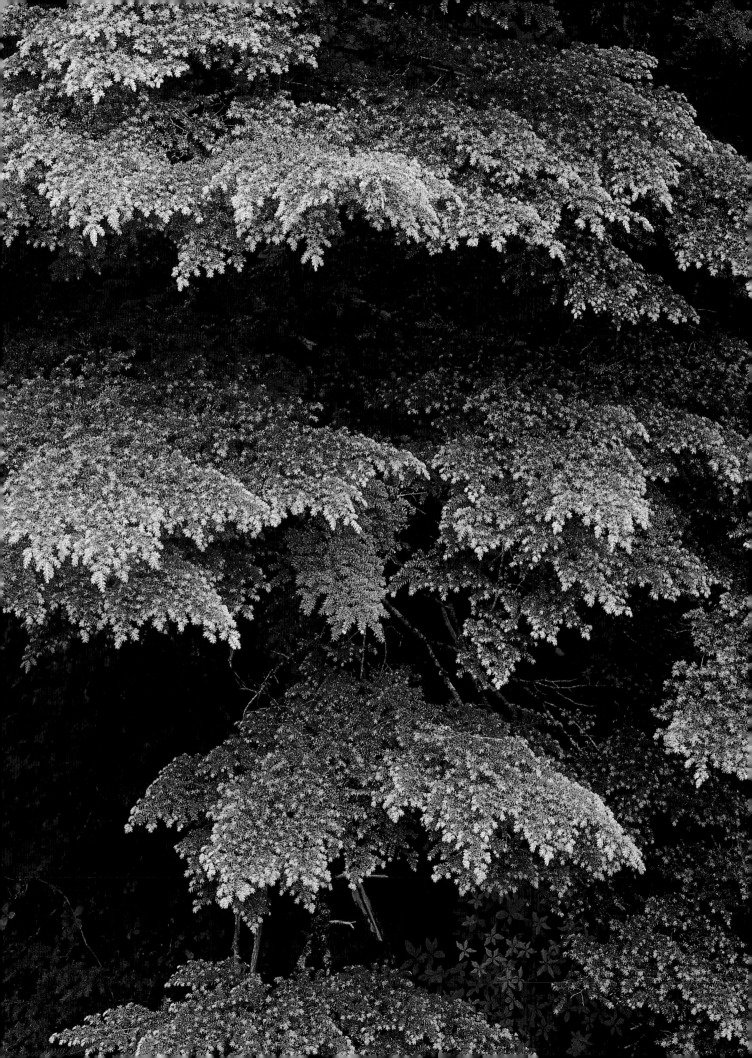

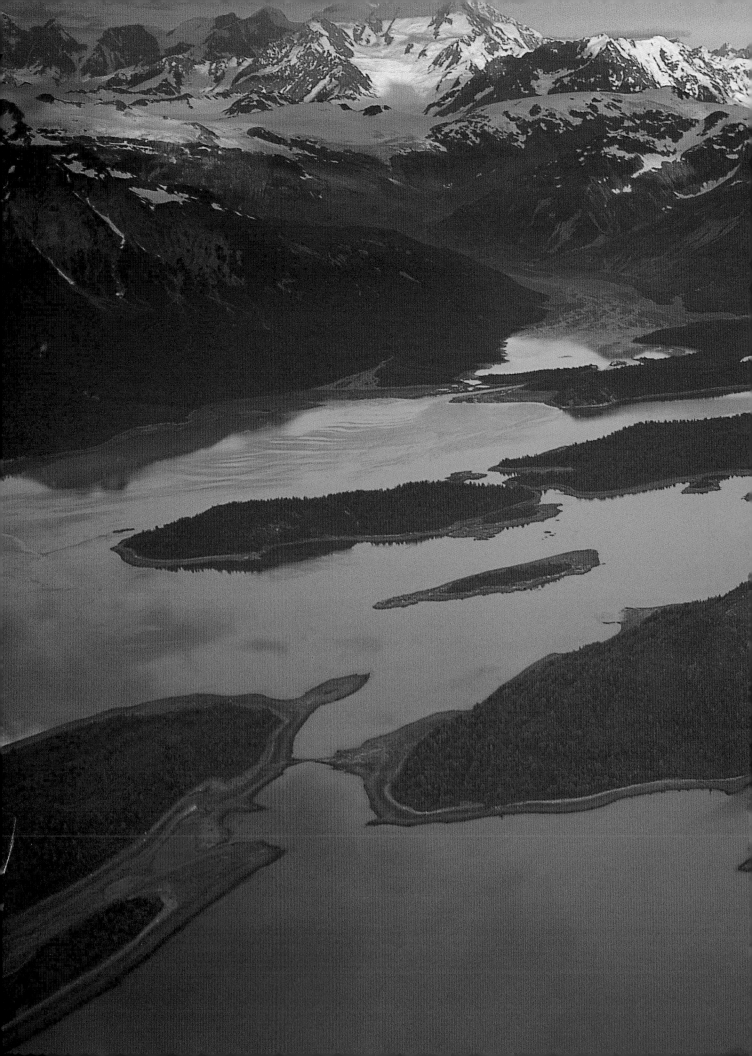

PORTRAIT OF
ALASKA'S
INSIDE
PASSAGE

PHOTOGRAPHY & ESSAY
BY KIM HEACOX

GRAPHIC ARTS CENTER PUBLISHING

International Standard Book Number 1-55868-316-X
Library of Congress Catalog Number 97-70191
Photographs © MCMXCVII by Kim Heacox
Essays © MCMXCVII by Graphic Arts Center Publishing Company
Published by Graphic Arts Center Publishing®
An imprint of Graphic Arts Center Publishing Company
P.O. Box 10306 • Portland, Oregon 97296-0306 • 503/226-2402
www.gacpc.com
President • Charles M. Hopkins
Editor-in-Chief • Douglas A. Pfeiffer
Managing Editor • Jean Andrews
Photo Editor • Diana S. Eilers
Designer • Robert Reynolds
Cartographer • Tom Patterson
Production Manager • Richard L. Owsiany
Production • Lincoln & Allen Co.
Printed in the United States of America
Ninth Printing

Page 1: Hikers investigate a meltwater pool on a glacier near Skagway. *Page 2:* Chilkat Dancer Charles Jimmie Sr. performs at Raven's Fort in Haines. *Page 3:* The branches of a western hemlock offer redemption on Prince of Wales Island, where more than half the old-growth rainforest has been logged. *Pages 4-5:* Early morning light dapples mountains and islands, evoking the intimacy of sea and shore that makes the Inside Passage so inviting. *Pages 8-9:* A cabin and fishing boat speak of escape at Baranof Warm Springs Harbor, on the east side of Baranof Island.

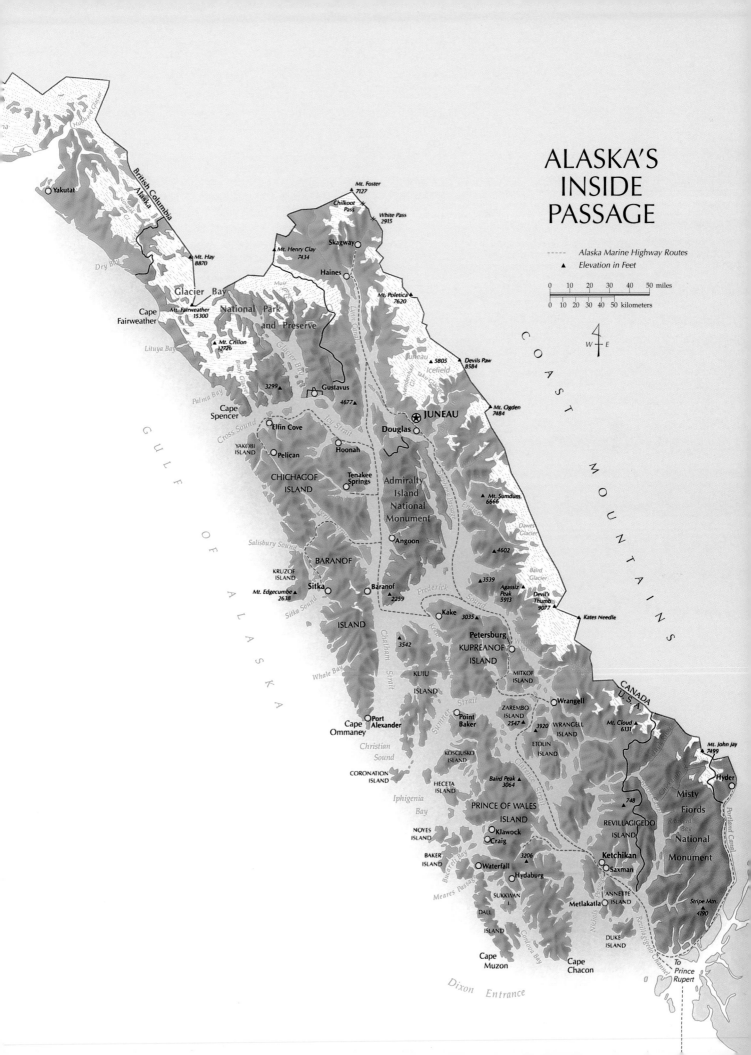

ALASKA'S INSIDE PASSAGE

--- Alaska Marine Highway Routes
▲ Elevation in Feet

0 10 20 30 40 50 miles
0 10 20 30 40 50 kilometers

W + E

○ Yakutat

British Columbia
Alaska

Hubbard Glacier

Mt. Foster
7127

Chilkoot
Pass

White Pass
2915

▲ Mt. Hay
8870

Skagway ○

▲ Mt. Henry Clay
7434

Haines ○

Dry Bay

Glacier Bay

Muir

Mt. Poletica
7620

National Park

Cape
Fairweather

▲ Mt. Fairweather
15300

and Preserve

Lituya Bay

▲ Mt. Crillon
12726

Glacier Bay

Juneau
Icefield

▲ 5805 ▲ Devils Paw
8584

Palma Bay

3299 ▲

Gustavus

Cape
Spencer

4677 ▲

Cross Sound

Icy Strait

Elfin Cove ○

★ JUNEAU

▲ Mt. Ogden
7484

Douglas ○

YAKOBI
ISLAND

Pelican ○

Hoonah ○

G U L F

CHICHAGOF
ISLAND

Tenakee
Springs ○

Admiralty
Island
National
Monument

▲ Mt. Sumdum
6666

Dawes Glacier

Salisbury Sound

BARANOF

Angoon ○

4602 ▲

O F

KRUZOF
ISLAND

3539 ▲ Agassiz
Peak
5913 ▲

Baird
Glacier

Devil's
Thumb
9077 ▲

Mt. Edgecumbe ▲
2638

Sitka ○

Baranof ○
2259 ▲

Frederick

Kates Needle ▲

A L A S K A

ISLAND

Sitka Sound

Sound

Kake ○ 3035 ▲

Whale Bay

3542 ▲

Chatham Strait

KUIU
ISLAND

Petersburg ○
KUPREANOF
ISLAND

CANADA
U.S.A.

Mt. Cloud
6131 ▲

Kake Strait

MITKOF
ISLAND

Cape
Ommaney

Port
Alexander ○

Point
Baker ○

ZAREMBO
ISLAND

Wrangell ○

Mt. John Jay
7499 ▲

Christian
Sound

Summer Strait

2547 ▲ 3920 ▲ WRANGELL
ISLAND

Hyder ○

KOSCIUSKO
ISLAND

ETOLIN
ISLAND

Misty

CORONATION
ISLAND

HECETA
ISLAND

Baird Peak ▲
3064

Clarence Strait

748 ▲

Fiords

REVILLAGIGEDO
ISLAND

National

Iphigenia
Bay

PRINCE OF WALES
ISLAND

Monument

NOYES
ISLAND

Klawock ○
Craig ○

3206 ▲

Ketchikan ○
Saxman ○

BAKER
ISLAND

Waterfall ○

Hydaburg ○

SUKKWAN
I.

Metlakatla ○

ANNETTE
ISLAND

Stripe Mtn.
4190 ▲

Meares Passage

DALL
ISLAND

Cordova Bay

DUKE
ISLAND

Cape
Muzon

Cape
Chacon

To
Prince
Rupert

Dixon Entrance

C O A S T M O U N T A I N S

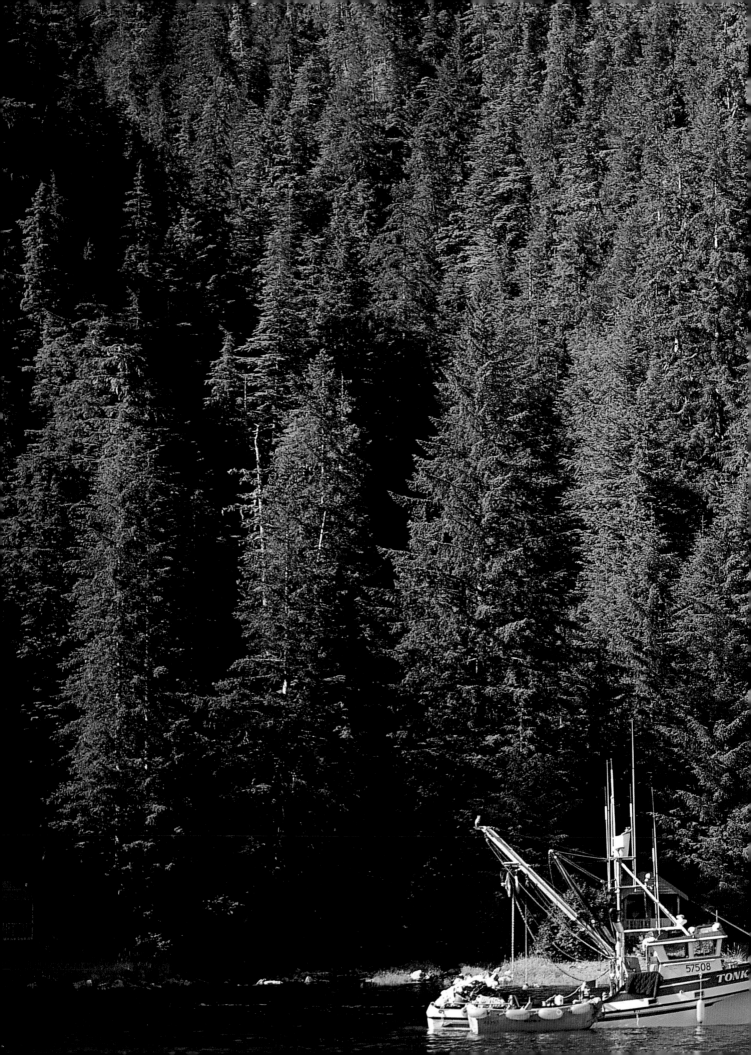

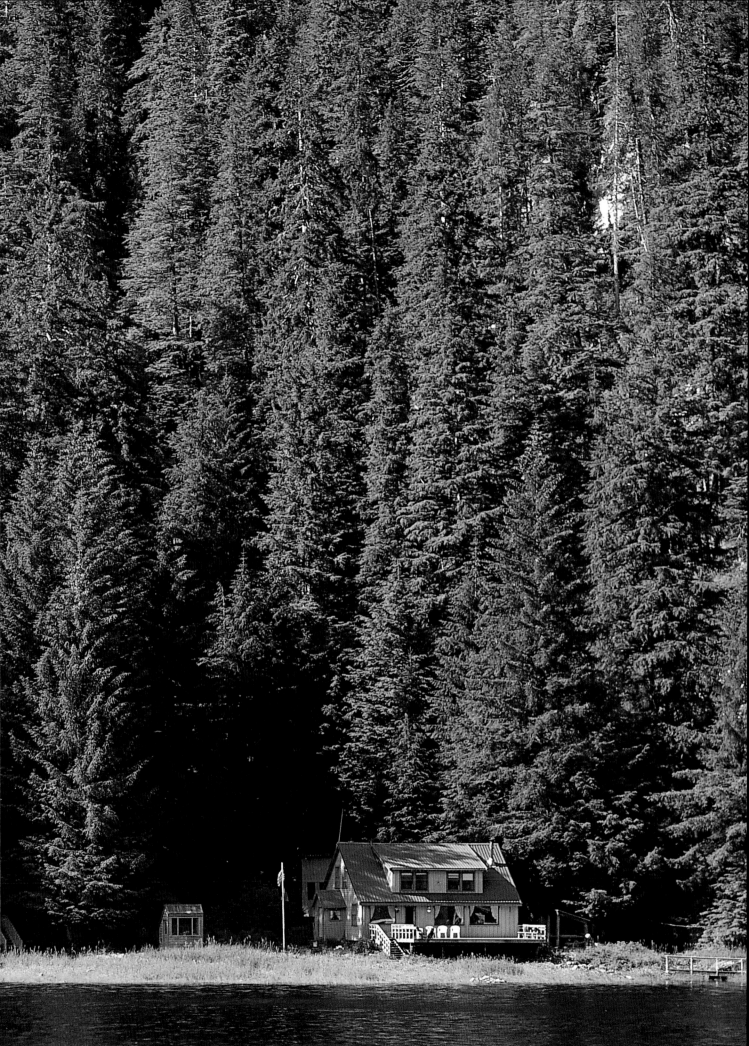

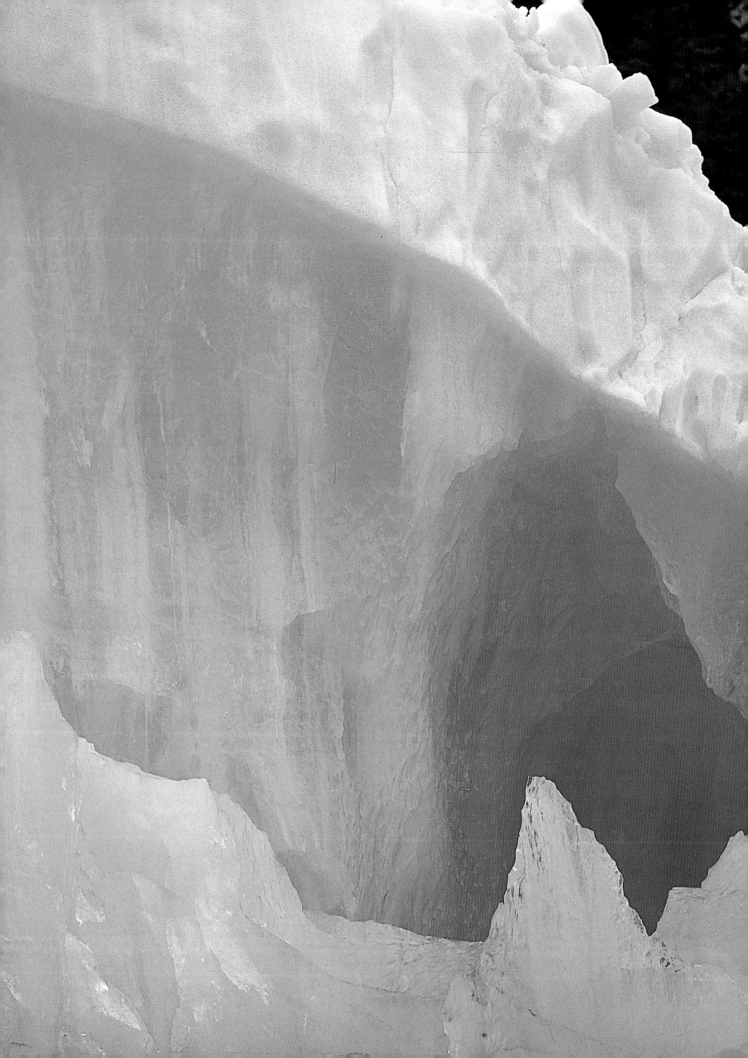

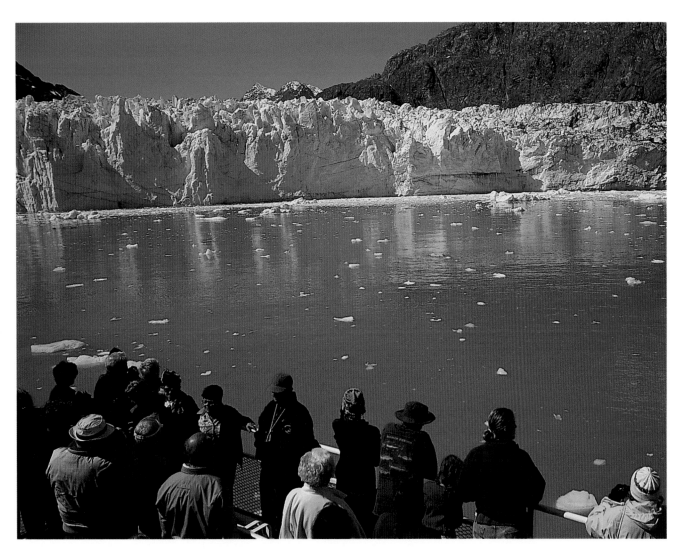

◁ Calved from the tidewater terminus of Dawes Glacier, a phantasmagoric iceberg drifts down Endicott Arm, in Tracy Arm-Fords Terror Wilderness, Tongass National Forest. △ Tourists crowd the railing of a cruise ship to admire Margerie Glacier, in Glacier Bay National Park. ▷ Mendenhall Glacier, called "the most accessible glacier in the world" (you can drive to it from downtown Juneau) advances through the Coast Mountains into Mendenhall Valley, framed by tall fireweed in Brotherhood Park.

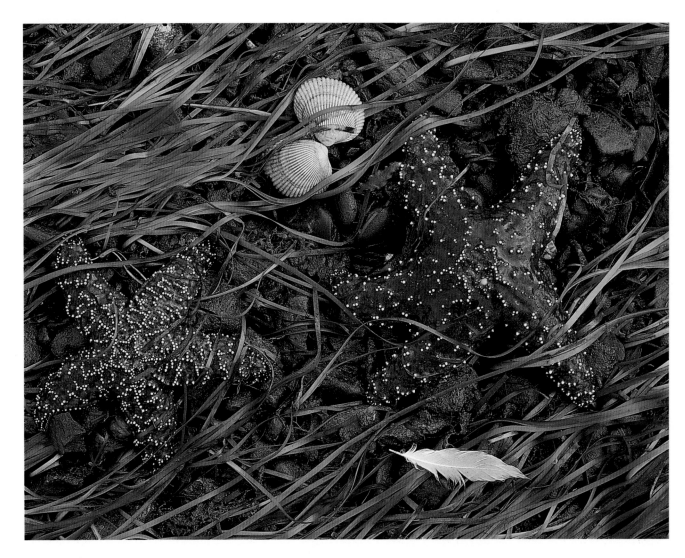

△ Starfish brighten the western coast of Baranof Island. This species, of the genus Pisaster, can exhibit many different colors. ▷ Chum salmon crowd into the mouth of Maybeso Creek, on Prince of Wales Island, in preparation for the upstream swim to spawning beds. All five species of Pacific salmon—sockeye, king, coho, pink, and chum—inhabit the Inside Passage and depend on its clean-running streams to reproduce and survive.

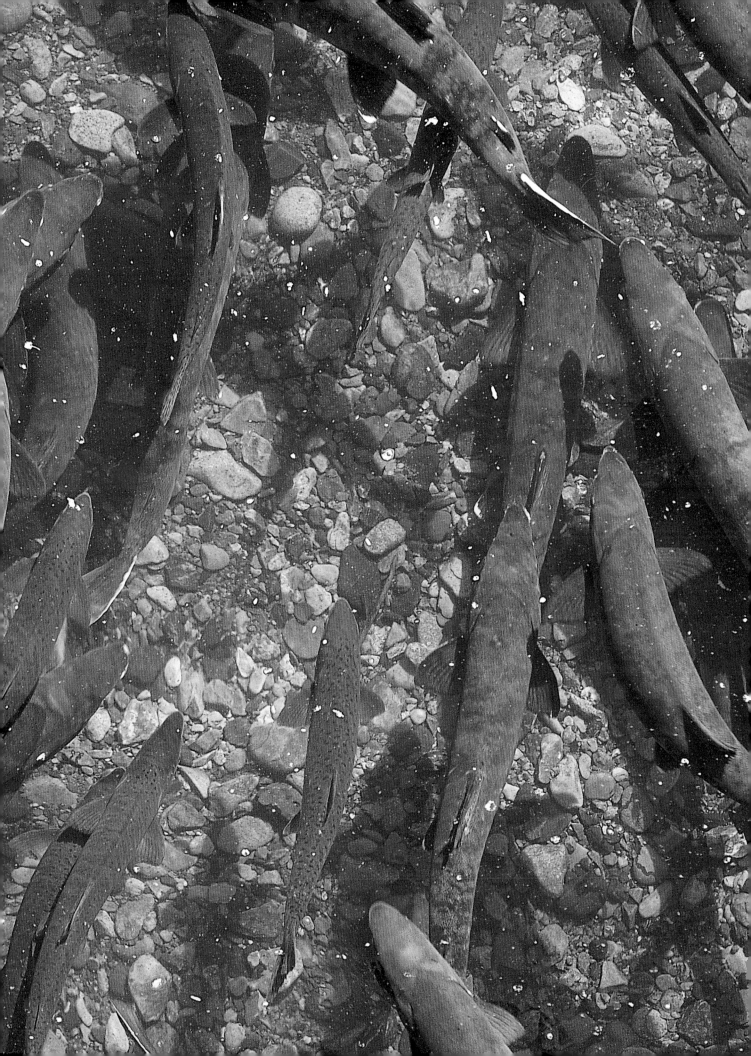

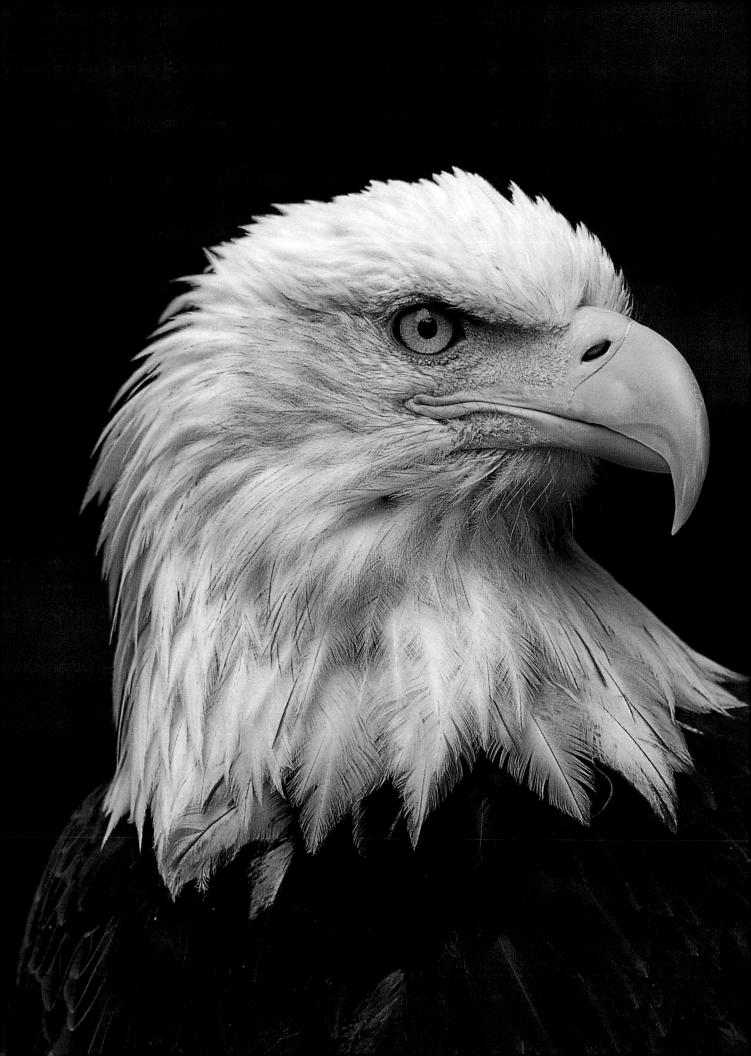

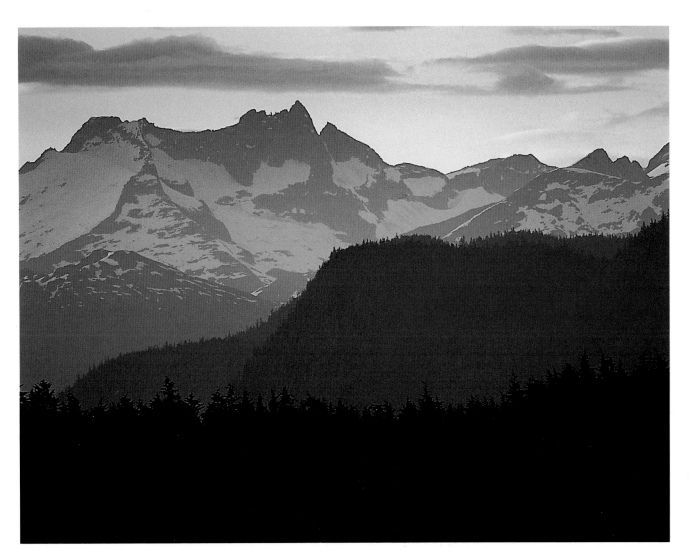

◁ An American bald eagle strikes a regal pose at the Alaska
Raptor Rehabilitation Center (ARRC), in Sitka. An estimated
fifteen thousand eagles live in Southeast Alaska, the strongest
population in North America. A private, nonprofit organization
founded in 1980, the ARRC treats more than fifty injured eagles
a year, plus other wildlife ranging from bats to mountain goats.
△ Mountains and forests provide an elegant backdrop—and
essential habitat—for eagles and other wildlife in Alaska.

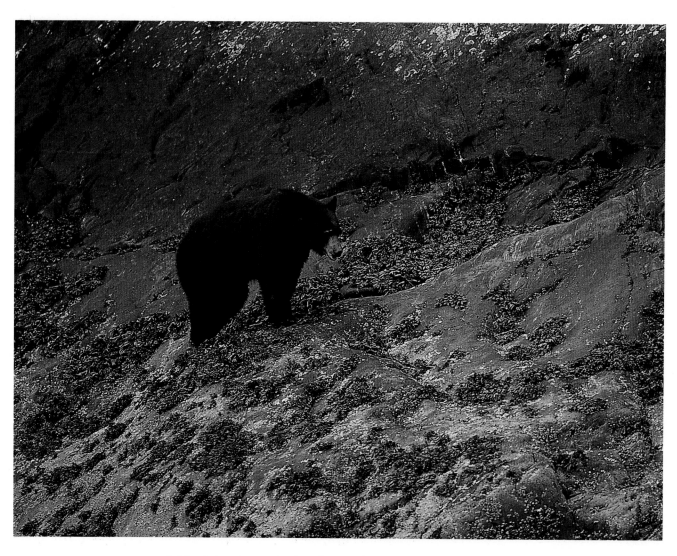

△ A black bear patrols the shore of Endicott Arm in search of barnacles and other edible intertidal life. ▷ A totem pole in Ketchikan speaks of a Native heritage filled with the power of wildlife: eagle, raven, wolf, bear, frog, salmon, and killer whale.

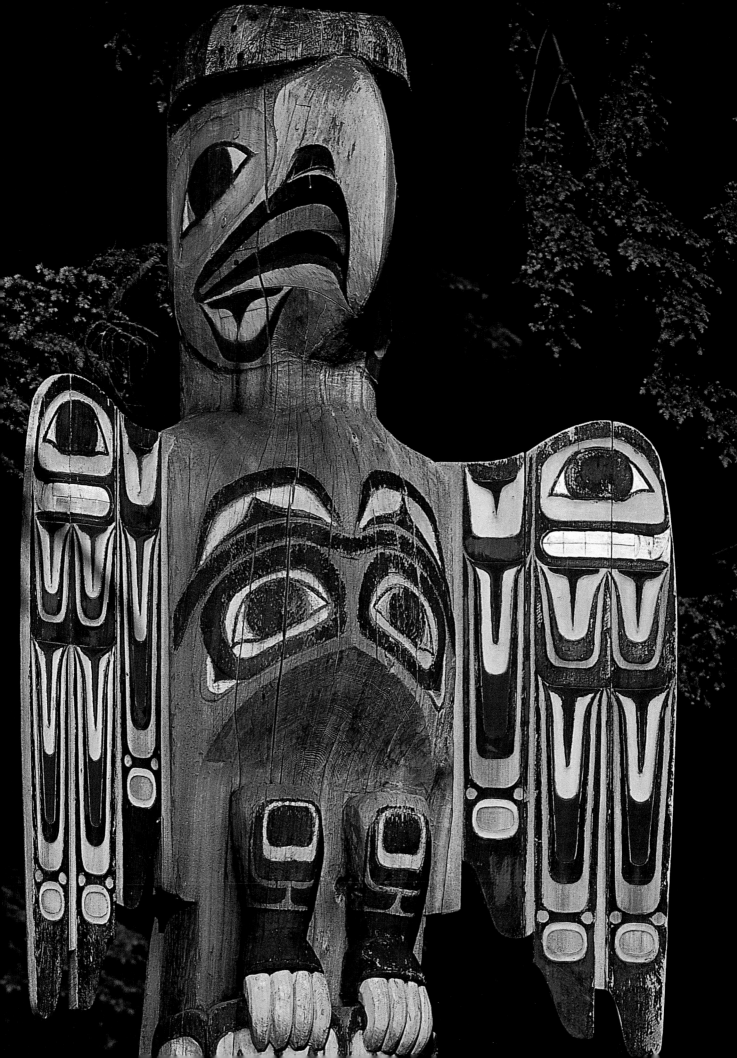

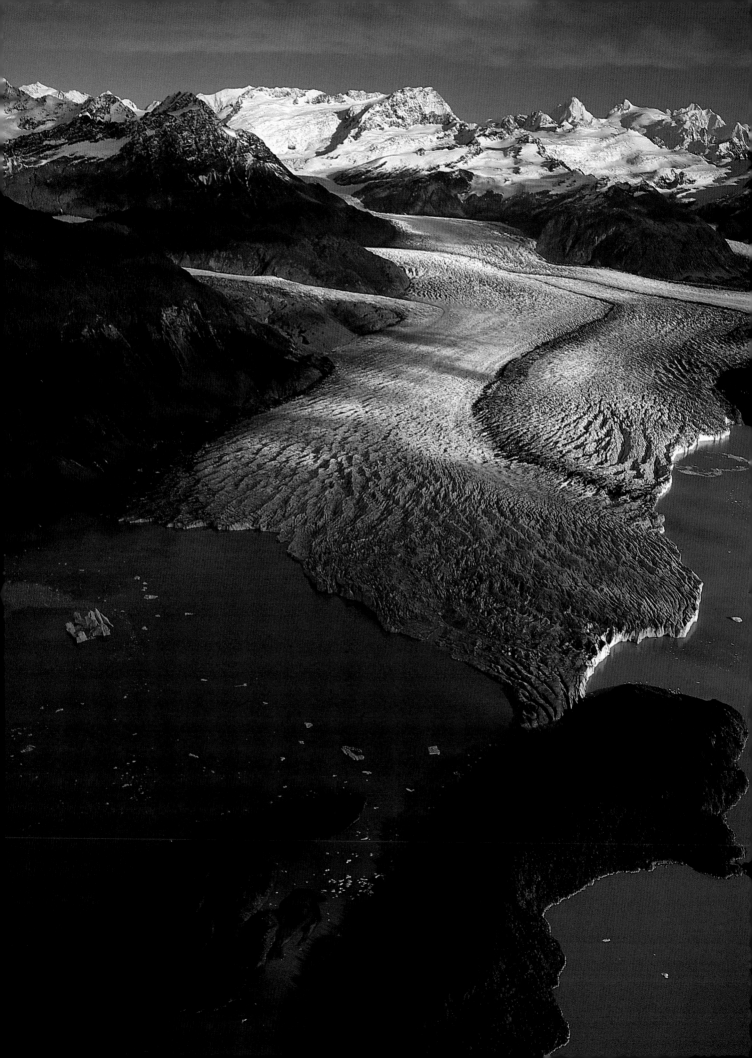

A Gift from Glaciers

He came from Cleveland and knew nothing of this Northern place: the verdant forests, the fang-like peaks, the intoxicating fiords that pulled him into a world where myth and fact became one. Ohio was nothing like this, never would be. He stood at the ship's railing for hours, lost in the immensity. Casual observation was not his style. He studied what he saw: the unbridled sea, the youthful topography, the restless elements of erosion and deposition. He watched for glaciers, the icy architects of this country, and pointed them out to four graduate students who traveled with him. He was a professor of geology from the Case School of Applied Sciences, a likable man with a good sense of humor. Alaskans on board might have considered him misplaced here, dressed in his Oxford tweed and unbroken boots, his city posture misfit in the unforgiving wilds, his fine features made all the more fragile behind rimless spectacles.

How wrong they would have been.

The professor's name was Harry Fielding Reid, and when on July 1, 1890, his steamer arrived off the tidewater terminus of Muir Glacier, in Glacier Bay, he bounded ashore and was thrilled to find camped there two men whose eagerness for Alaska rivaled his own, for one of them was John Muir himself, the famous naturalist whose eyes were no less blue than the glacier named in his honor.

The historical record is incomplete, but their meeting was no doubt lively. And they no doubt discussed glaciers. Both Reid and Muir hungered to learn about the great ice rivers, how they sculpted mountains and excavated fiords; why some advanced while others retreated. How fast did they flow? How old was the ice? So many questions, so little time.

More than twenty years earlier, Muir had theorized that glaciers, not primal cataclysm, had created his beloved Yosemite Valley in California's Sierra Nevada.

To see ice rivers first hand he had traveled to Alaska first in 1879, and together with a Presbyterian missionary and four Tlingits—Native peoples of the area—paddled by dugout canoe from Fort Wrangell to the frigid, berg-filled waters of Glacier Bay, a world that exceeded his deepest longings for wild country. Describing a climb above camp one night near Geike Inlet, Muir wrote, "All the landscape was smothered in clouds and I began to fear that as far as wide views were concerned I had climbed in vain. But at length the clouds lifted a little, and beneath their gray fringes I saw the berg-filled expanse of the bay, and the feet of the mountains that stand above it, and the imposing fronts of five huge glaciers, the nearest being immediately beneath me. This was my first general view of Glacier Bay, a solitude of ice and snow and newborn rocks, dim, dreary, mysterious."

Too dim and dreary for the Tlingits. They spoke of evil spirits and weak hearts, of canoes crushed in ice and sad wives back home who would never see their husbands again. We must turn around, they petitioned Muir; we must leave this treeless place. Muir listened. He was engaged to be married himself the following spring, and thus sympathized with the Tlingits, but he would not be dissuaded. With brilliant oratory he lifted the Tlingits' hearts and inspired them to paddle farther up the bay, deeper into the ice and cold where, with his beard waving wildly in the wind, he extolled the grand works of glaciers.

Now, in 1890, eleven years later, Muir was back. Diagnosed in California with a bronchial cough and nervous indigestion, he had decided to return north and hike again the wild contours he felt would cure him. Camped on his namesake glacier after crossing a labyrinth of crevasses, he wrote, "I am cozy and comfortable here resting in the midst of glorious icy scenery." Near the end of his forty-mile journey, he fell

◁ *Alsek Glacier travels downslope from the St. Elias Mountains to empty into Alsek Lake. Alaska boasts more than one hundred thousand glaciers, most of them small and unnamed. Yet two, the Bering and Malaspina, near Yakutat, are roughly the size of Rhode Island.*

into a crevasse and submerged himself in the ice cold water. Pulling on wet, long underwear the next morning, he said, "was a miserable job, but might have been worse," for he realized that his cough was gone. He concluded that, "No lowland grippe microbe could survive such experiences." Meeting him on his return was his new friend, Professor Reid.

Two years later, in 1892, while John Muir founded the Sierra Club in California, Professor Reid returned to Glacier Bay, this time to the West Arm, where again he mapped glacial positions and rates of flow. Camping in the rain, Reid wrote, "We have concluded that there are many infallible signs of rain in this region. If the sun shines, if the stars appear, if there are clouds or if there are none; these are all sure indications. If the barometer falls it will rain; if the barometer rises, it will rain; if the barometer remains steady, it will continue to rain."

Alaska then, as now, was not for the faint-of-heart, or for the humorless. It was a place to begin anew, to reflect, to win or lose but never remain the same. It offered hope, a second chance, a world still fresh and young, and so attracted scholars and scoundrels, miners and misfits, poets and pretenders.

Sailing north his fifth and final time in 1899 as a member of the Harriman Alaska Expedition, John Muir, now 61, signed the register as an "author and student of glaciers." Other members of the expedition included a who's who of distinguished American scientists, artists, and photographers, all financed by the famous railroad magnate, Edward H. Harriman. Like his old friend Harry Fielding Reid, Muir leaned on the railing and drank deeply of Alaska. Wilderness was his elixir—he could not have enough of it: the salutation of land and sea; the fertile shore with birds, bears, and deer; the thousand islands and ten thousand miles of coastline that are the essence of Southeast Alaska.

And the focal point of it all, the Inside Passage, that magical waterway that invites travelers into the heart of surprise, like a ribbon around a gift, serving up one tantalizing view after another of American wildness. Of this journey through the Inside Passage, Muir wrote, "Were the attractions of this north coast half-known, thousands of lovers of nature's beauties would come hither every year. I know of no excursion in any part of our vast country where so much is unfolded in so short a time."

By 1899, however, tremendous changes had come to Southeast Alaska. Gold had been discovered on the Stikine River and in Canada's Cassiar district in 1861 and 1872, each new discovery bringing waves of prospectors through Fort Wrangell. In 1880, Joe Juneau and Richard Harris hit paydirt along Gastineau Channel, where Alaska's capital city would one day thrive. And in 1896 on Rabbit Creek, a quiet tributary of Canada's Klondike River, a gold strike of mythic proportion spawned one of the largest tides of human migration in recorded history: an estimated one hundred thousand men and women who stampeded north to reinvent themselves and the lands they would settle.

At the head of Lynn Canal and Taiya Inlet—the world's longest fiord—where the Inside Passage ends one thousand nautical miles north of Seattle, the boomtowns of Skagway and Dyea were born. "The beach had become a human anthill," wrote historian Pierre Berton, "a confused melee of swearing men and neighing horses, of rasping saws and sputtering camp-fires, of creaking wagons and yelping dogs—a jungle of tents and sheet iron stoves and upturned boats scattered between the mountainous piles of goods and hay. Atop these sprawling heaps, knee deep in flour sacks and frying pans, perspiring men bawled out the names on every outfit and tossed them down to the waiting owners. . . . Above the beach, in the forested

flatland, the town of Skagway was still taking shape, a shifting and changing melange of shacks and tents, crammed with men frantic to get over the trail and into the Klondike before freeze-up."

John Muir was not impressed. To him, all gold was fool's gold. He believed no metal or piece of jewelry could rival the beauty of an untouched mountain or undefiled stream. Amid the madness he found his dear friend, S. Hall Young, the missionary who had traveled with him in Glacier Bay twenty years earlier, and asked him to join the Harriman Expedition. Young declined, citing more serious work at hand. Chief among Young's concerns were the Natives of Southeast Alaska: the Tlingit and Haida whose cultures were being trampled beneath the juggernaut of gold stampeders and other whites.

For countless generations the Tlingit and Haida had lived and prospered on the fertile shores of Southeast Alaska, the Tlingits to the north, the Haida to the south. They had no word for starvation, no concept of capitalism. The land and sea were not theirs to own, nor were they anyone else's to take.

These Native Americans were master seafarers who traveled in canoes up to seventy feet long, fifty men to a canoe, hunting seals, fishing for halibut, trading or warring with others near and far. On shore they picked berries, harvested shellfish, and caught trout, herring, a small, oily fish called eulachon (hooligan), and all five species of Pacific salmon: king, silver, sockeye, pink, and chum. To commemorate a significant hunt or catch, such as the first salmon of summer, a Tlingit family would place the bones of the animal nearby as they ate, or beside the stream from where it came, and bless their good fortune.

The natural bounty of the Inside Passage afforded the Tlingit and Haida ample leisure time to become great artists; to create blankets, baskets, bracelets, and totem poles that were both functional and ceremonial. The bold totemic motifs and crests—raven, eagle, bear, beaver, wolf, frog, killer whale, and watchman—have come to symbolize Alaska's Inside Passage as much as the land and sea and wild animals that inspired them.

An estimated ten thousand Tlingit and Haida lived here when Vitus Bering and Alexi Chirikof, sailing for Russia, dropped anchor in 1741, initiating the European discovery of Alaska. In a few short decades the Russians spread along the coast like a virus. They killed and indentured Aleuts (Natives of the Aleutian Islands), displaced Tlingits, and commanded the harvest of sea otters with devastating efficiency. In 1802, at Sitka, the Tlingits struck back, burning buildings and killing all but a few of the occupying Russians and Aleuts. Alexander Baranof, then chief manager of the Russian-American Company and not a man to be trifled with, retaliated in 1804 by shelling the Tlingits from ships at sea and reclaiming the site he called New Archangel—today's Sitka. The Tlingits were invited back (to their aboriginal home) in 1821, and by 1845 Sitka was the "Paris of the Pacific," the busiest seaport on the western coast of America.

With sea otters hunted to near extinction, Russia sold Alaska to the United States in 1867 for 7.2 million dollars, roughly two cents an acre. Even as the Stars and Stripes was raised on Sitka's Castle Hill, the old Russian Capitol, the American press shook its editorial head. Here was a nation in need of rebuilding itself after a terrible Civil War, and what does it do? Buys an "icebox"? Cartoonists called it "Seward's Folly," in dubious honor of Secretary of State William Seward, the crazy coot who engineered the purchase.

Who needs Alaska?

Sailing the Inside Passage in 1899, members of the Harriman Expedition began to believe that all

Americans needed Alaska. Not just for its natural resources, but for its wildness and beauty, its tonic and teachings, its ability to enrich us from afar by our just knowing it is there, big as we imagined—bigger. Historians William H. Goetzmann and Kay Sloan, writing many decades later, described 1899 as "an age of strange binocular vision that was at times replete with irony. Essentially, the Harriman expeditioners saw two Alaskas—one, the stunning, pristine land of forests and mountains and magnificent glaciers; the other, a last frontier, being invaded by greedy, rapacious, and sometimes pathetic men, often living out a false dream of success."

Here, the Expedition members believed, was a chance for American redemption, to save what had been destroyed from Connecticut to California: entire ecosystems, Native cultures, unblemished panoramas. Wrote Henry Gannett, the chief geographer of the U.S. Geological Survey, "For the one Yosemite of California, Alaska has hundreds." All of them pristine. Would they remain so? Gannett concluded, "The Alaska coast is to become the show-place of the earth, and pilgrims, not only from the United States, but from beyond the seas, will throng in endless procession to see it. Its grandeur is more valuable than the gold or the fish or the timber, for it will never be exhausted."

John Muir concurred.

Gold, fish, and timber had their champions, however. By 1897, Peter Buschmann, a Norwegian immigrant, had settled along Wrangell Narrows with his wife and children. With an abundance of salmon and halibut, it seemed a good spot for a year-round fishery. Nearby LeConte Glacier, the southernmost tidewater glacier in North America, provided icebergs fishermen could use to pack and send their halibut south. Thus was born the town of Petersburg, "Alaska's Little Norway."

Ketchikan, too, had stirred to life. The original Tlingit fishing camp had grown into a salmon saltery, then a dozen canneries, and by 1900 this roll-up-your-sleeves town was packing more than twenty-five thousand cases of salmon per year. Ketchikan became the "Salmon Capital of the World." Mining and the timber industry were not far behind.

It was an exhilarating time: the Klondike Gold Rush, the salmon bonanza, the cedar and spruce forests just waiting to be cut. Alaska had become the new Big Rock Candy Mountain, where dreamers said fish jumped into your net and dollars grew on trees and every day was payday. The truth was in fact as cold as Southeast Alaska rain. To survive here required hard work; to prosper required wits and imagination. It still does.

The Inside Passage could steal your heart away, if you let it, if you sailed the generous sea, walked the fertile shore, and sought the silence as John Muir did. Watching men cut the giant Sequoias and redwoods in California, he lamented, "Any fool can destroy a tree." And he questioned: would they do it in Alaska?

In 1907, President Theodore Roosevelt, an admirer of Muir, signed into existence Tongass National Forest, covering 77 percent of Southeast Alaska. Originally 15.5 million acres and increased to 16.9 million acres in 1980, it is the nation's largest national forest. Yet it is not inviolate. As Muir feared, many of the tallest, straightest trees in the Tongass, particularly on Prince of Wales and Chichagof Islands, have been cut down and shipped to the Orient as raw logs or pulp. A national outcry against this government subsidized overharvest finally forced pulp mills in Sitka and Ketchikan to close in the 1990s.

The two Alaskas observed by the Harriman Expedition a century ago—one for the taking, the other for the saving—exist to this day. Fishermen and

loggers, pilots and politicians, gardeners and artists, middle-of-the-bell-curvers and end-of-the-roaders, nearly all seventy thousand people who live in thirty-three communities in Southeast Alaska care deeply about the future of this enchanted yet changing place. They speak about who they are, what they believe, how they belong.

They sip Alaskan Amber beer or black coffee and speak of the poetry of tides, the prose of weather, the power of wildlife. They consider Admiralty Island, which contains roughly seventeen hundred brown bears—one per square mile, the greatest density of brown bears in the world. No wonder Tlingits called it *Kootznahoo,* "Fortress of the Bears." They speak of wolves on Prince of Wales Island, and of glacier bears, a gray race of the black bear, in Glacier Bay. They speak of metric tons of salmon, thousands of bald eagles, hundreds of sea otters—yes, sea otters, once nearly exterminated, now making a comeback.

One coffee drinker says a pod of Orcas, killer whales, were seen attacking two moose that swam across Icy Strait. Another claims six black bears were seen eating shoreline barnacles in Tracy Arm. That's nothing, says another: a guy in a kayak in Frederick Sound had a dozen humpback whales lunge-feeding around him for an hour, and not one of the huge mammals—adults forty feet long, weighing forty tons—tipped him over or touched his kayak. The stories never end, stories of grand adventures and everyday life, for when you live along the Inside Passage, life itself is an adventure.

Granted, it rains. In fact it pours. Ketchikan averages 162 inches (13.5 feet) of rain per year, where people say, "If you can't see Deer Mountain, it's raining. If you *can* see it, it's about to rain." Other parts of Southeast Alaska receive upwards of four hundred inches. While most outsiders see this rain as a curtain, Alaskans see it as a blanket, a talisman that affords them peace and identity. The rain makes them who they are; it keeps them unique. Moreover, as Harry Fielding Reid and John Muir understood, rain at sea level means snow up high, and it is snow—layer upon layer—that eventually makes the Inside Passage what it is; that compresses into glacial ice, flows down-slope, and carves mountains and creates fiords.

This is the ice-wrought legacy of the region. As great glaciers occupied northern North America twelve thousand years ago, excavating the Great Lakes and depositing Manhattan Island and Cape Cod on one side of the continent, they sculpted canals, channels, and inlets on the other side. Ice covered the land thousands of feet higher than sea level today. And in fact until just two hundred years ago glaciers occupied all of Glacier Bay, a body of water nearly seventy miles long and in some places ten miles wide. What John Muir and Harry Fielding Reid discovered more than a century ago was a bay emerging from the cold grip of the Little Ice Age, or Neoglacial Period, not unlike the last great Ice Age that had gripped nearly all of Southeast Alaska many millennia earlier.

Alaska's Inside Passage is a gift from glaciers. The fertile shore, the generous sea, the feathered forests, the hamlets and homesteads, the cruise ships and ferry boats and countless adventures—all arise from contours carved by ice. No wonder Alaskans take strength from the wildness around them. No wonder that when it rains, it pours. Yet when it shines, with sunlight dancing off ice, water, forest, and rock, no place is more stunning. People stand for hours at a ship's railing, lost in the beauty.

Fisheries boom and bust, and boom again. Pulp mills come and go. Fortunes rise and fall. Yet Alaska's Inside Passage endures best only when received for what it is: a gift.

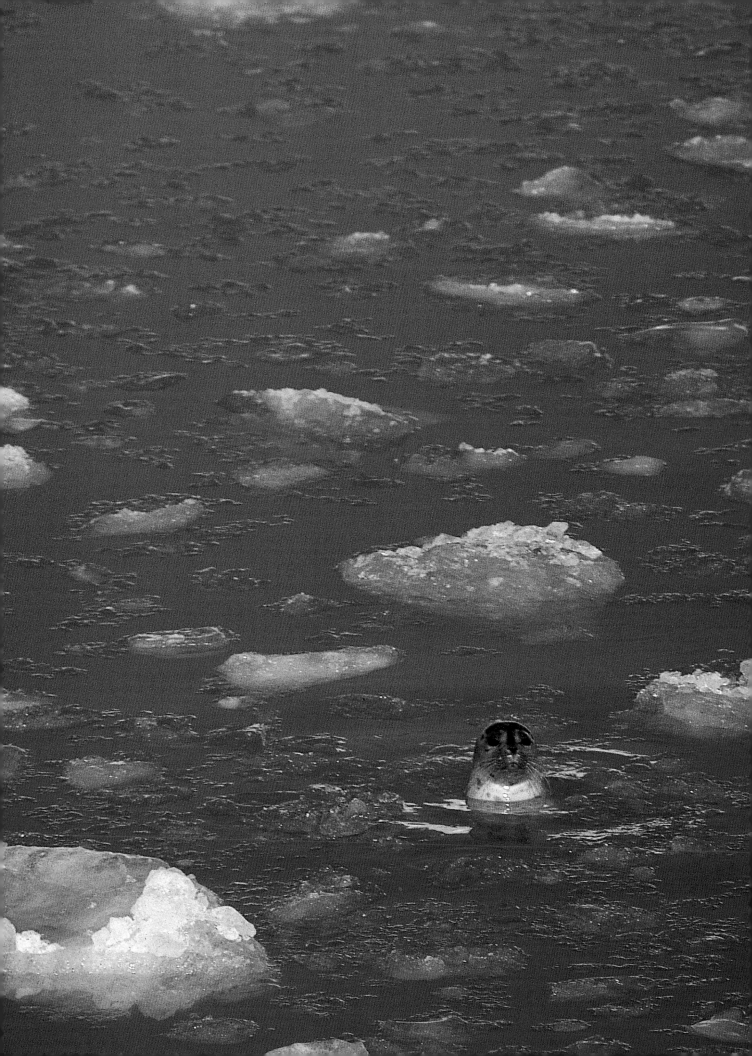

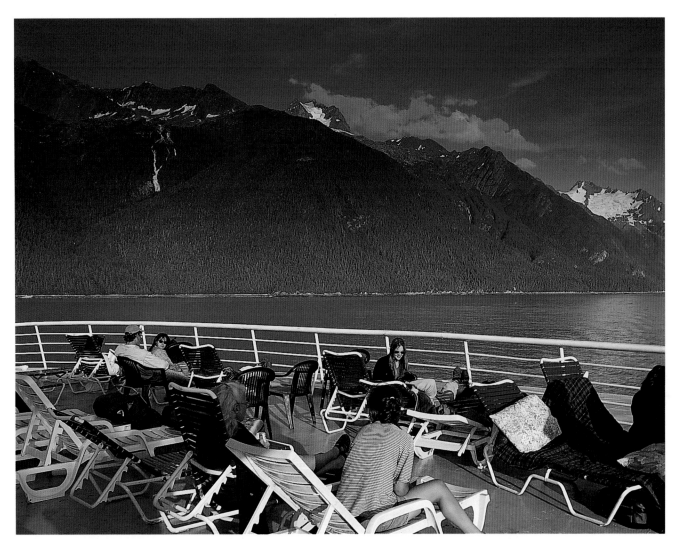

◁ A harbor seal inspects its world amid the icebergs in Tarr
Inlet, Glacier Bay. △ Passengers relax on the solarium of the
M/V *Columbia,* the largest of Alaska's State Ferries, as it travels
up Chilkoot Inlet, near Haines. ▷ A Haines Airways Piper
Cherokee takes passengers flightseeing over upper Carroll
Glacier, in Glacier Bay National Park. Flights over this type of
terrain offer great rewards without disturbing the peace and
quiet of campers and kayakers along inlet shores.

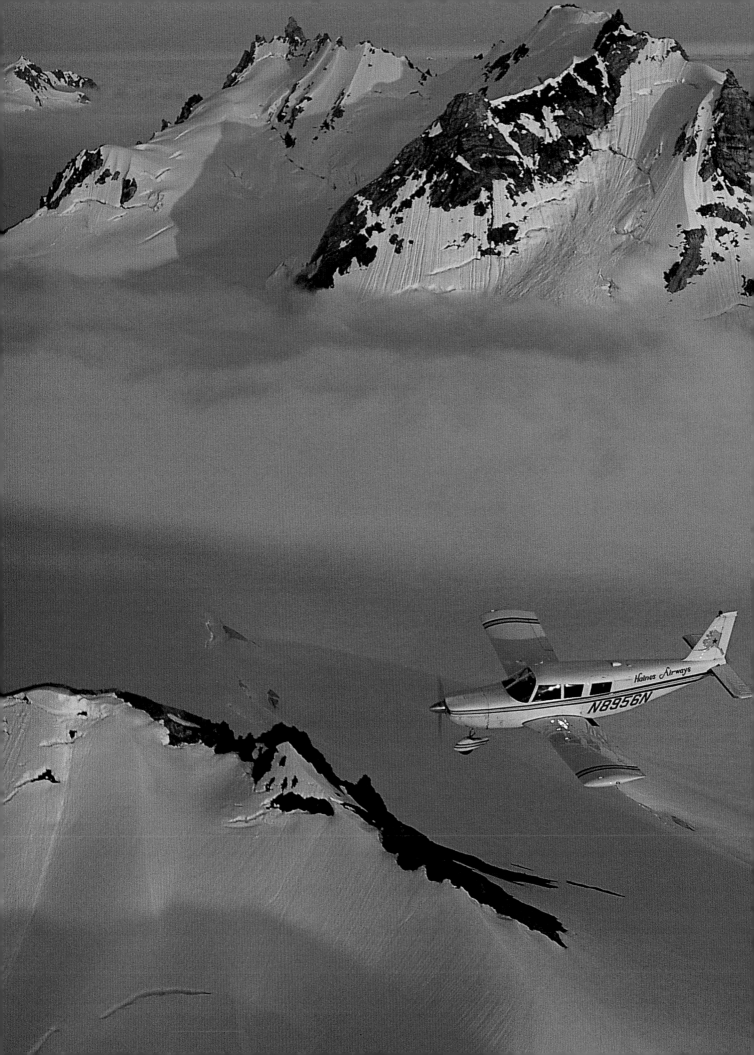

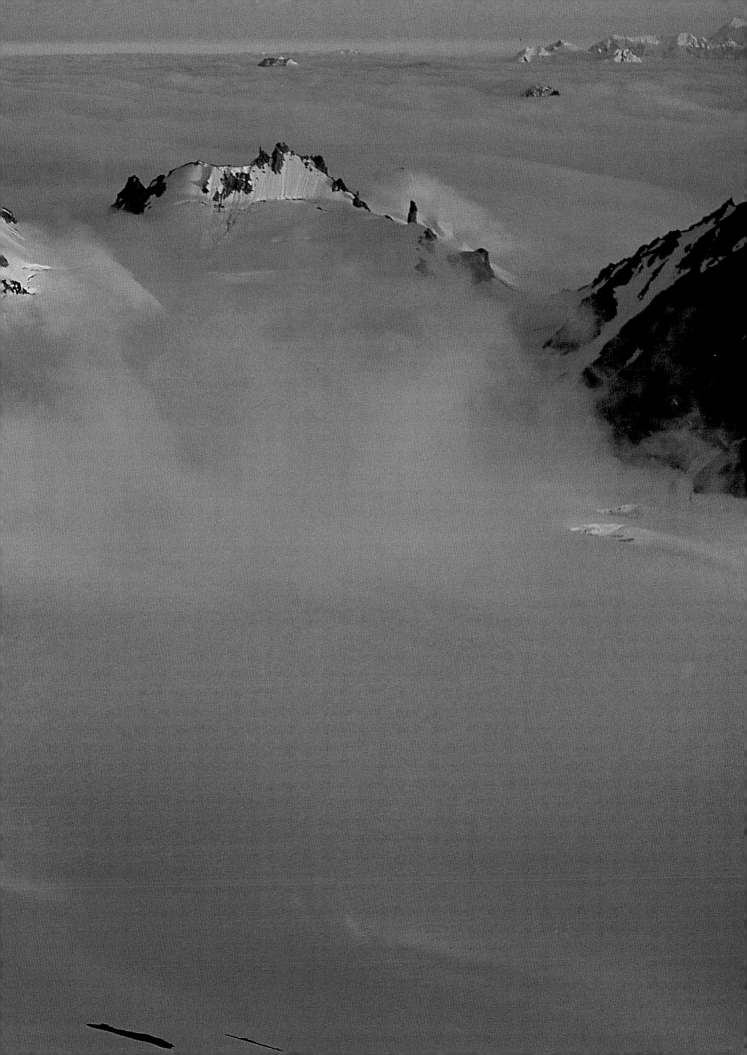

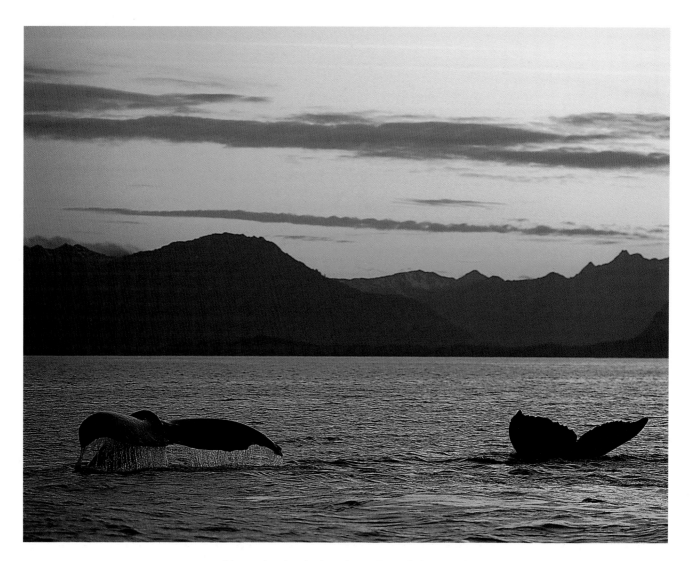

△ A pair of humpback whales show their flukes as they dive at sunset in Chatham Strait. Because their numbers are only about 10 percent of what they were before whaling, humpback whales are protected by the Endangered Species Act and the Marine Mammal Protection Act. Most humpbacks that summer in Alaska spend their winters in Hawaii. ▷ A recent rain anoints shooting stars with pearls of water. Botanists have catalogued more than nine hundred species of vascular plants (trees, ferns, and flowers) in Southeast Alaska.

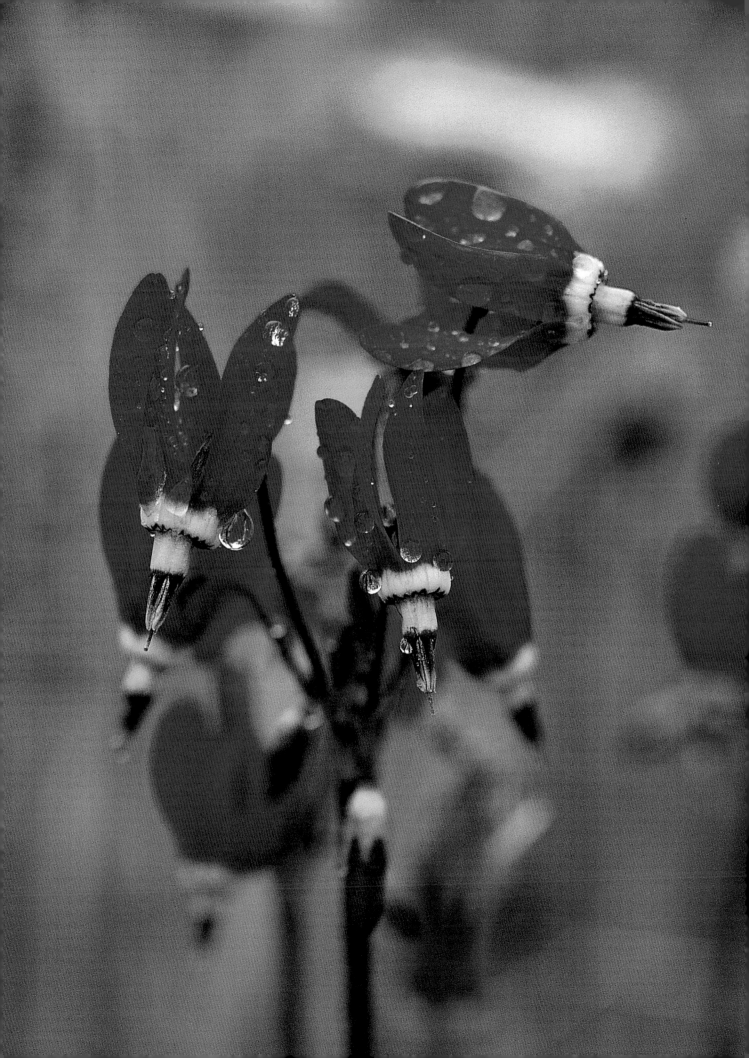

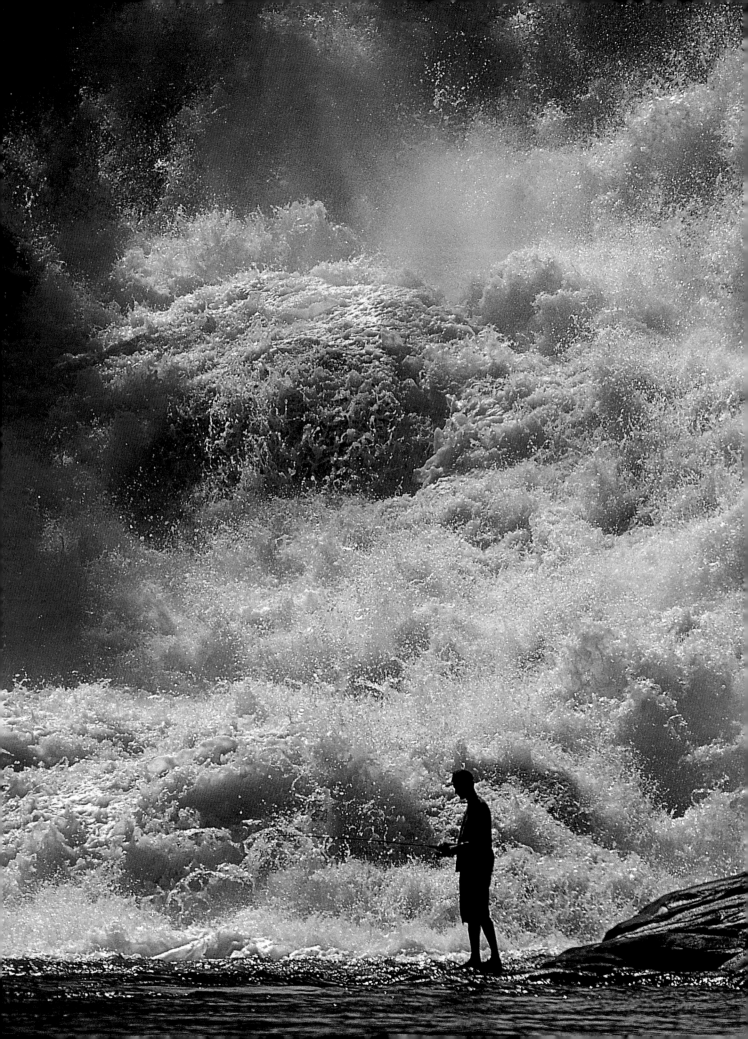

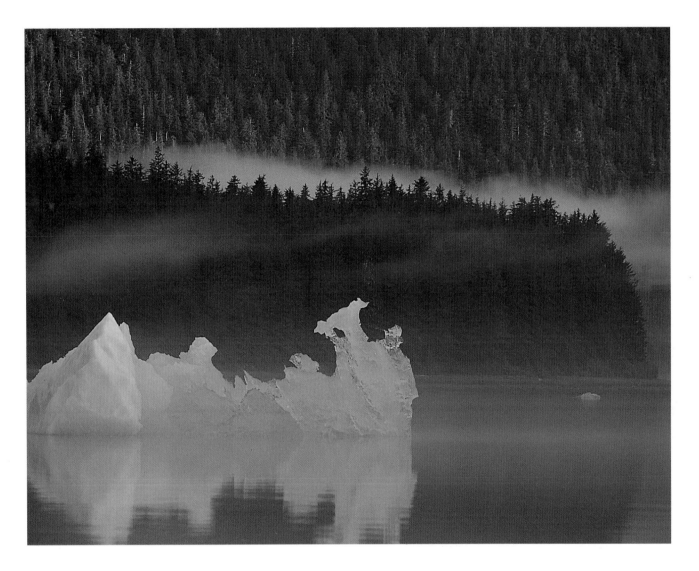

◁ Dwarfed by Baranof Falls, a lone fisherman tests his mettle in Baranof Warm Springs Harbor. Salmon are not the only fish that inhabit these still-vibrant waters; others are trout, sculpin, Dolly Varden char, flounder, halibut, sablefish, herring, sole, smelt, poachers, gunnels, and prowfish (to name a few). Southeast Alaska is home to some three hundred fish species (freshwater and salt), representing sixty-five taxonomic families. △ Morning fog veils forest and iceberg in Endicott Arm.

△ What childhood could be misspent in a place where the air, water, and land are free of pollution and crime? Such is life on the northwest shore of Chichagof Island, in the fishing hamlet of Elfin Cove, home to a handful of resourceful families. Timbermen have attempted to cut the forests near here, but Elfin Covers appreciate their trees standing, and have rebuffed them. ▷ Summer's flowers brighten crab pots stored along the shore of Wrangell Narrows, on Mitkof Island, near Petersburg.

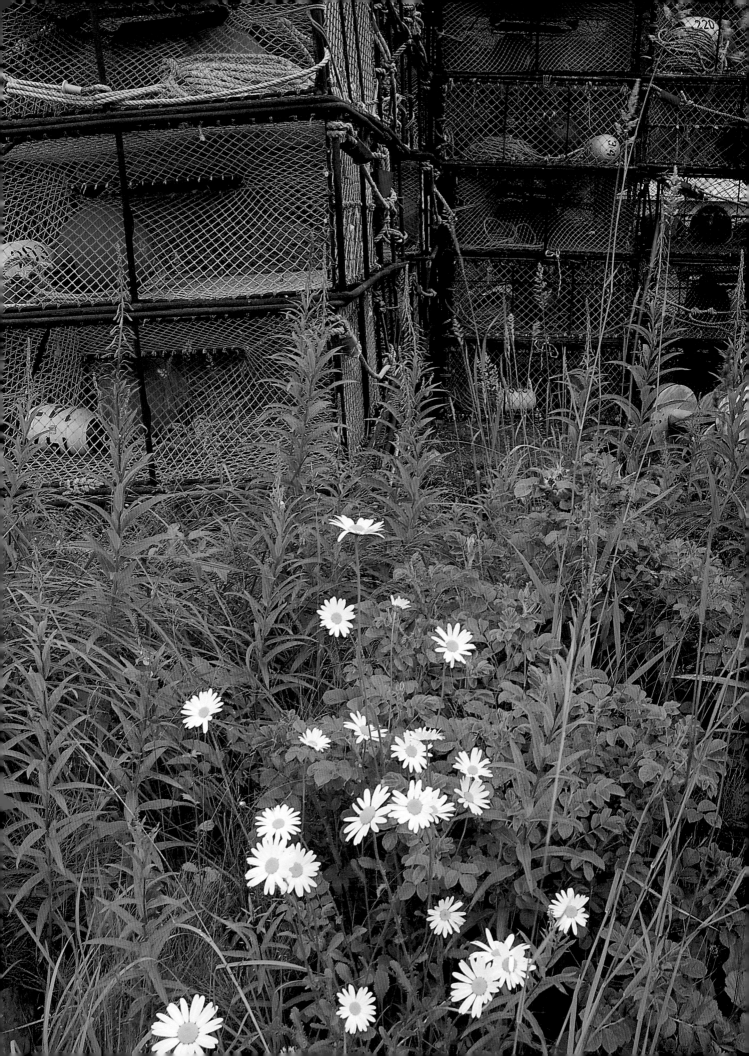

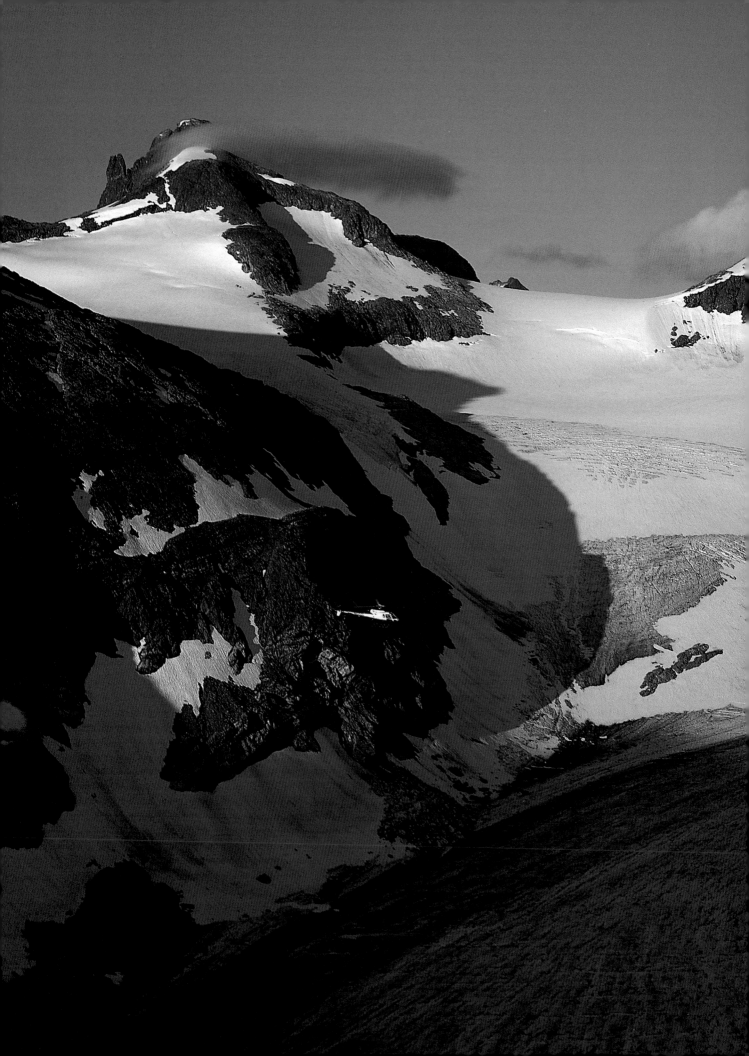

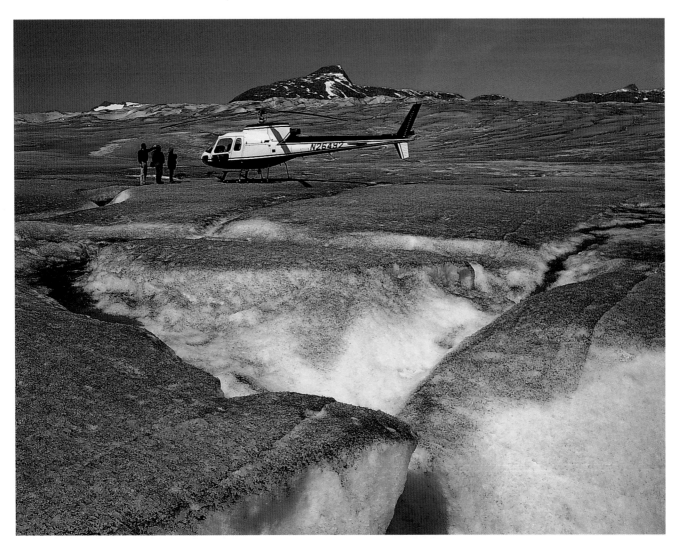

◁ A flightseeing helicopter hovers over Lemon Creek Glacier, near Juneau, Alaska's capital city. △ In recent years, helicopter excursions have skyrocketed in popularity, as tens of thousands of tourists fly over and land upon nearby glaciers each summer. While most helicopter rides follow a prescribed route, a few are "pilot's choice" and fly to remote destinations, such as here on the Taku Glacier. The flipside is that helicopters now invade wilderness areas that were once peaceful and quiet.

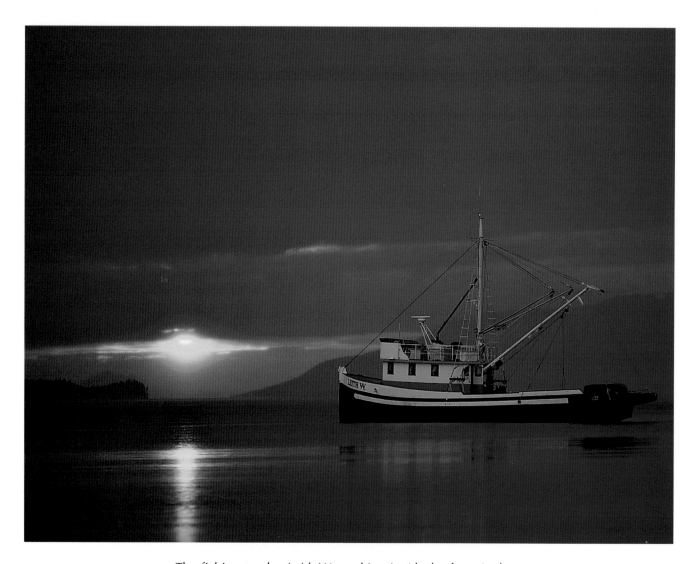

△ The fishing tender *Leith W*, working in Alaska from its home port in Washington State, anchors in Endicott Arm's Sanford Cove, as rain clouds advance over a colorful sunset in early June. ▷ A female great-horned owl stares with predatory eyes from its forest home on Baranof Island. ▷ ▷ The hamlet of Haines stands proudly beneath the Chilkat Range. Many of these buildings are part of old Fort William H. Seward, constructed by the U.S. Army in 1903, renamed Chilkoot Barracks in 1922, and designated a national historic site in 1972.

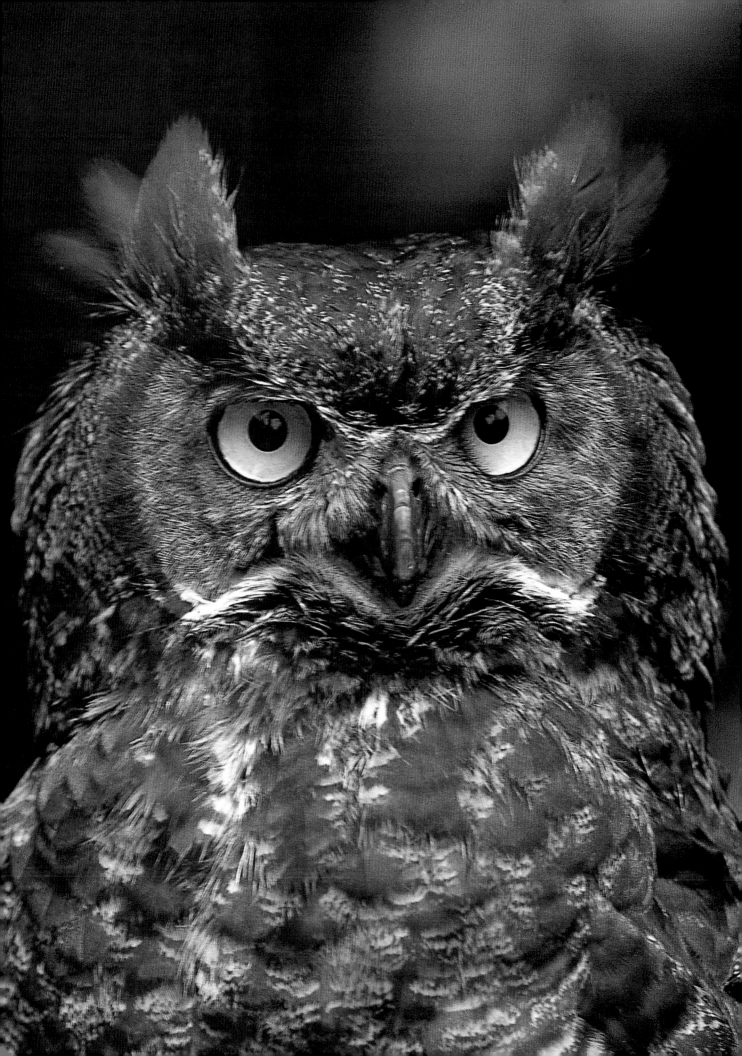

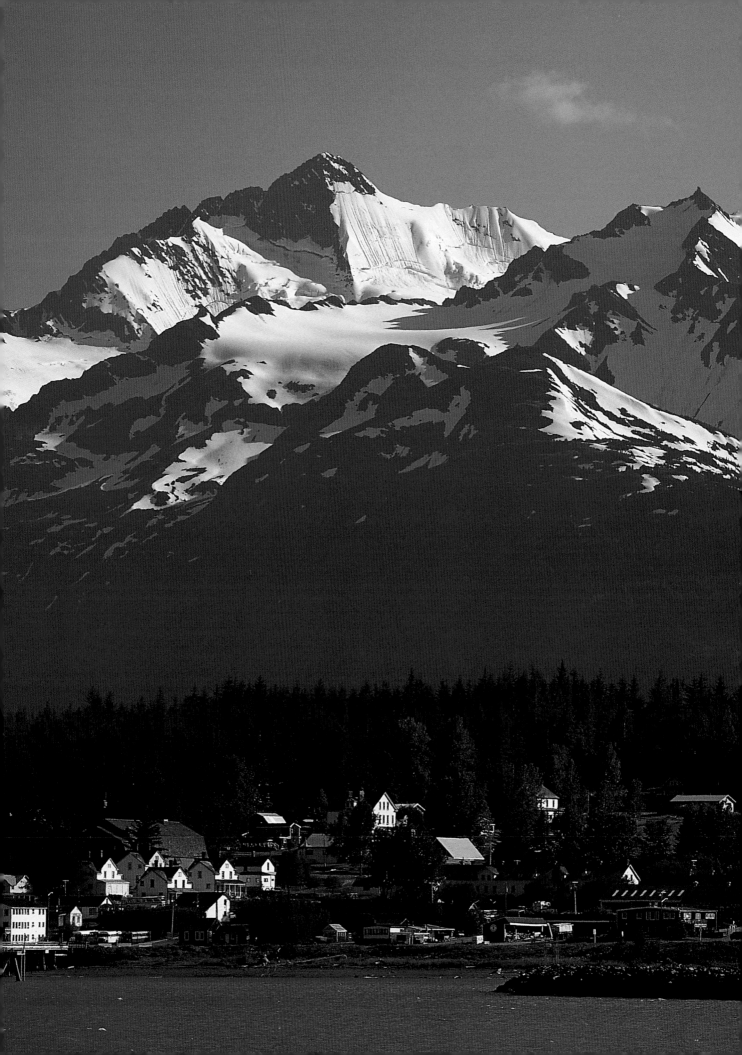

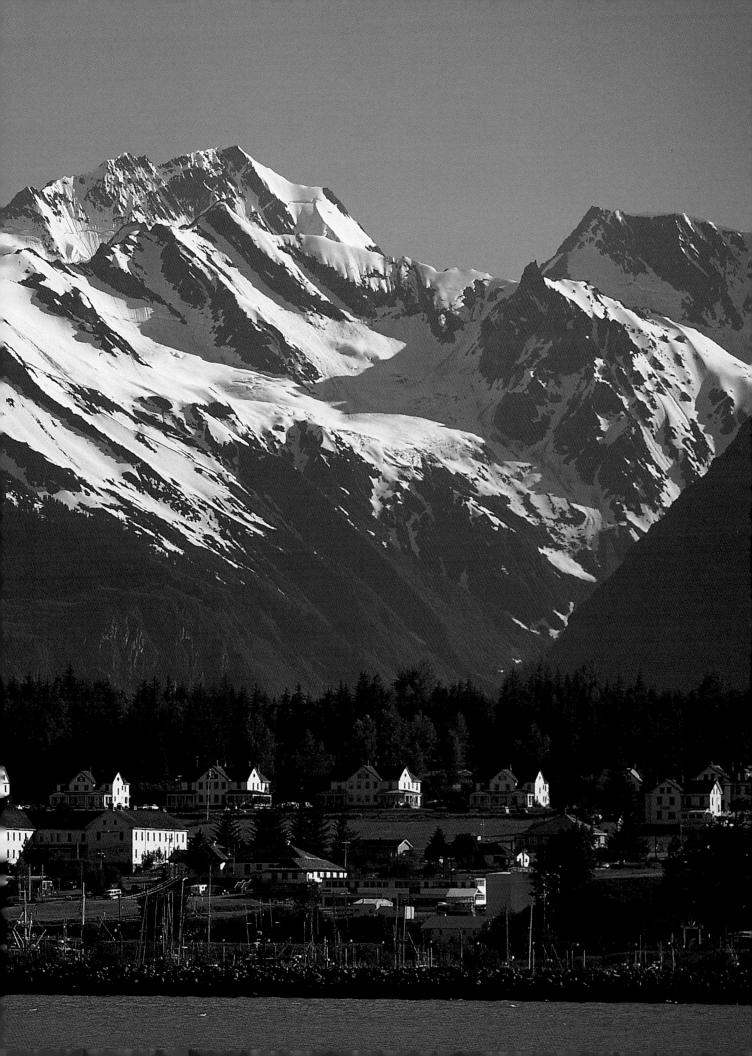

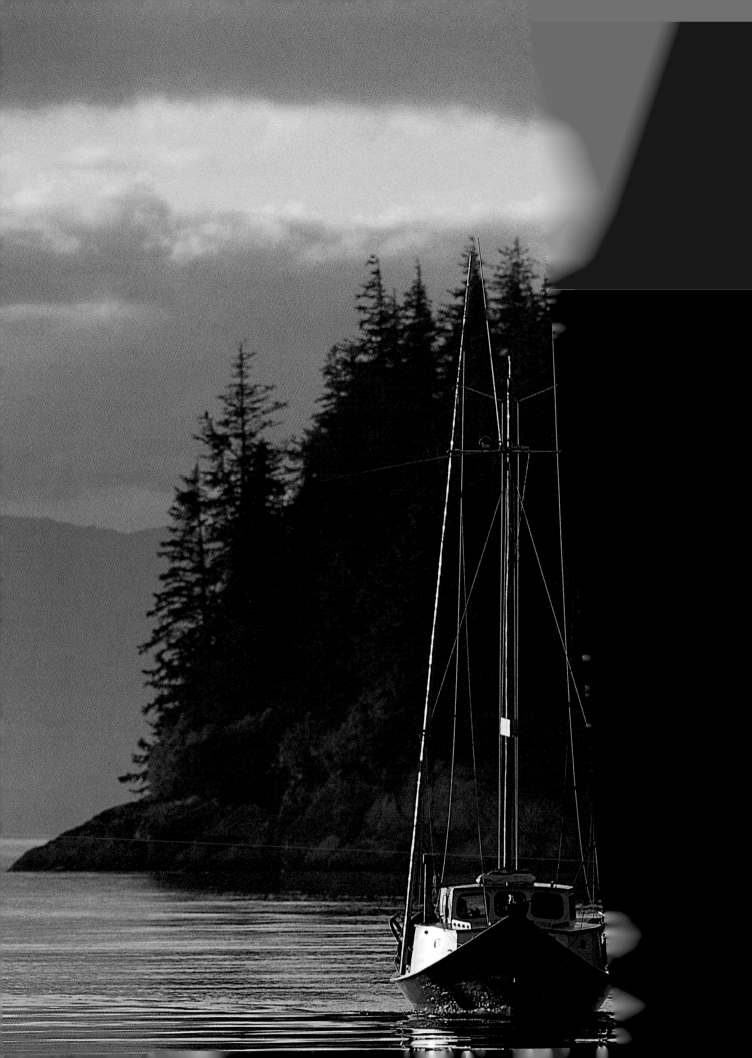

◁ A commercial troller enters the quiet sunset waters of Elfin Cove after a day of fishing in Icy Strait. Approximately six billion pounds of fish and shellfish are caught commercially in Alaskan waters each year. △ Building your own home, growing your own garden, and cutting your own firewood are essential to free spirits who make their homes along the Inside Passage. These people live simple, unincorporated lives, and make no more demands on others than they do on themselves.

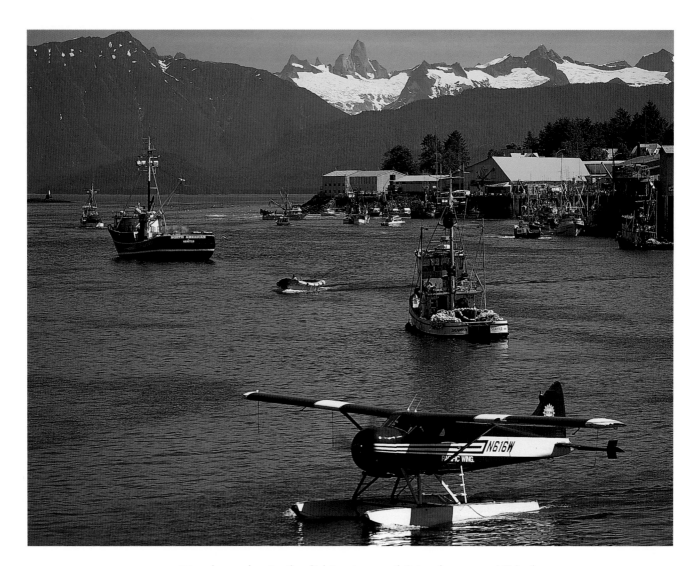

△ It's a busy day in the fishing town of Petersburg, on Mitkof Island at the north end of Wrangell Narrows, where traffic consists of boats and planes more than trucks and cars. In the distance stand the ragged summits of the Coast Mountains, most distinctly the 9,077-foot spire, Devil's Thumb, on the Alaska-British Columbia International Boundary. ▷ The Whiting River flows through the Tongass National Forest into Port Snettisham.

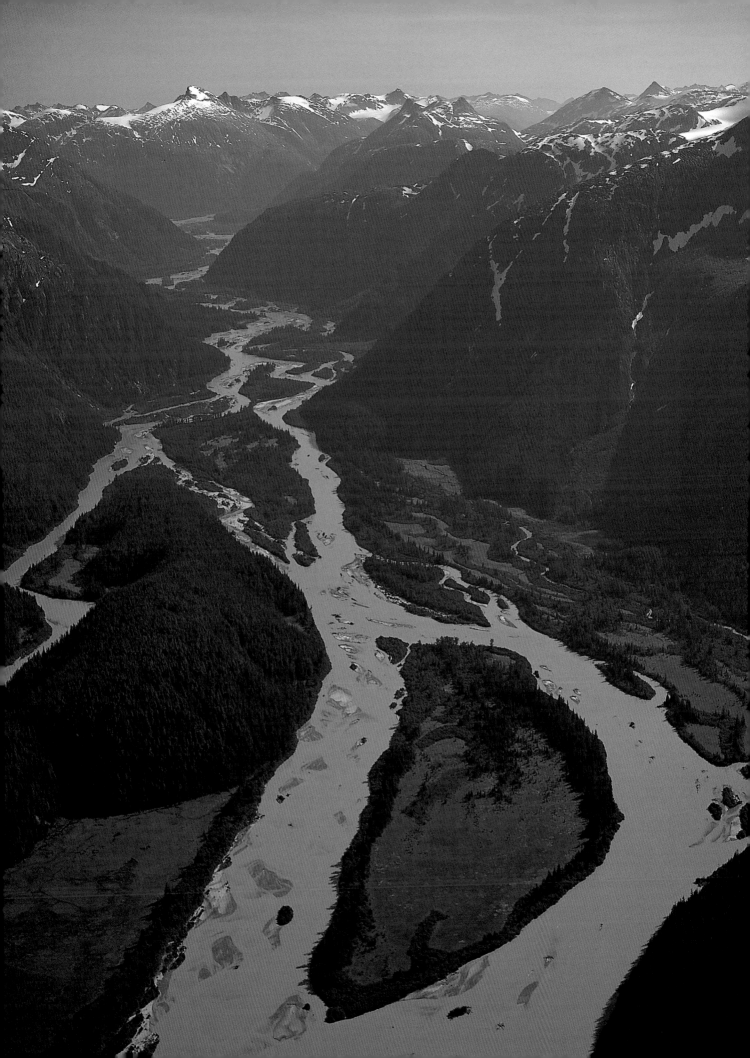

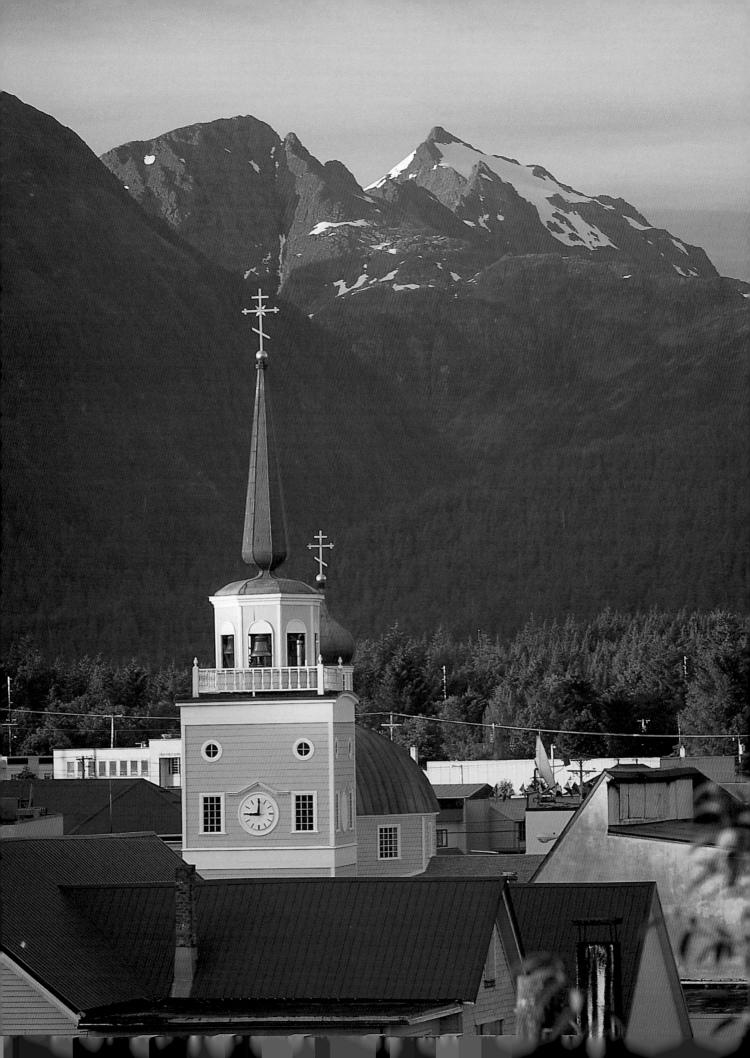

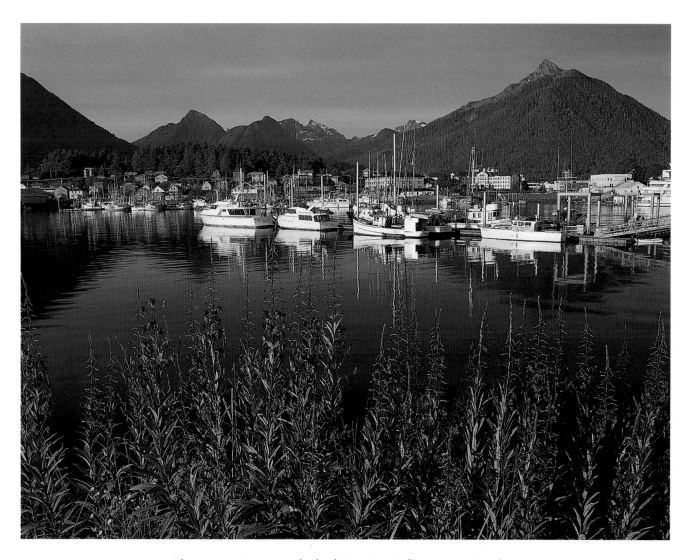

◁ The preeminent symbol of Russian influence in Southeast
Alaska, Saint Michael's Russian Orthodox Cathedral rises above
other less memorable rooftops in Sitka. Built in 1844-48, the
original cathedral burned down in 1966. Townspeople braved
the flames to save many priceless Russian icons, and in 1976
Saint Michael's was reconstructed using the original blueprints.
△ Tall fireweed brightens Sitka's boat harbor, with the mountains
of Baranof Island cutting a jagged skyline behind.

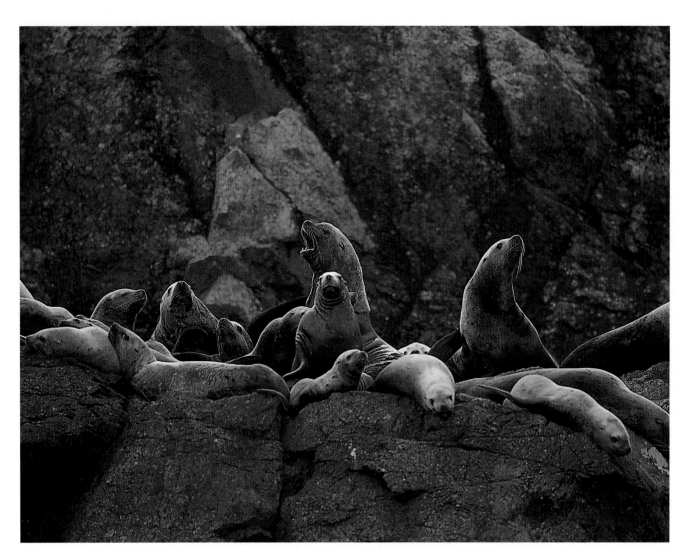

△ Steller's sea lions gather on Yasha Island, in Frederick Sound. While their numbers have remained stable in Southeast Alaska, they have collapsed in the Gulf of Alaska and Bering Sea, likely due to human overfishing of walleye pollock, an important feed fish for sea lions. ▷ Seabeach sandwort (also known as beach greens) forms mats along the high tide line in Glacier Bay's West Arm, a living laboratory for the study of glacial recession, plant succession, and wildlife immigration.

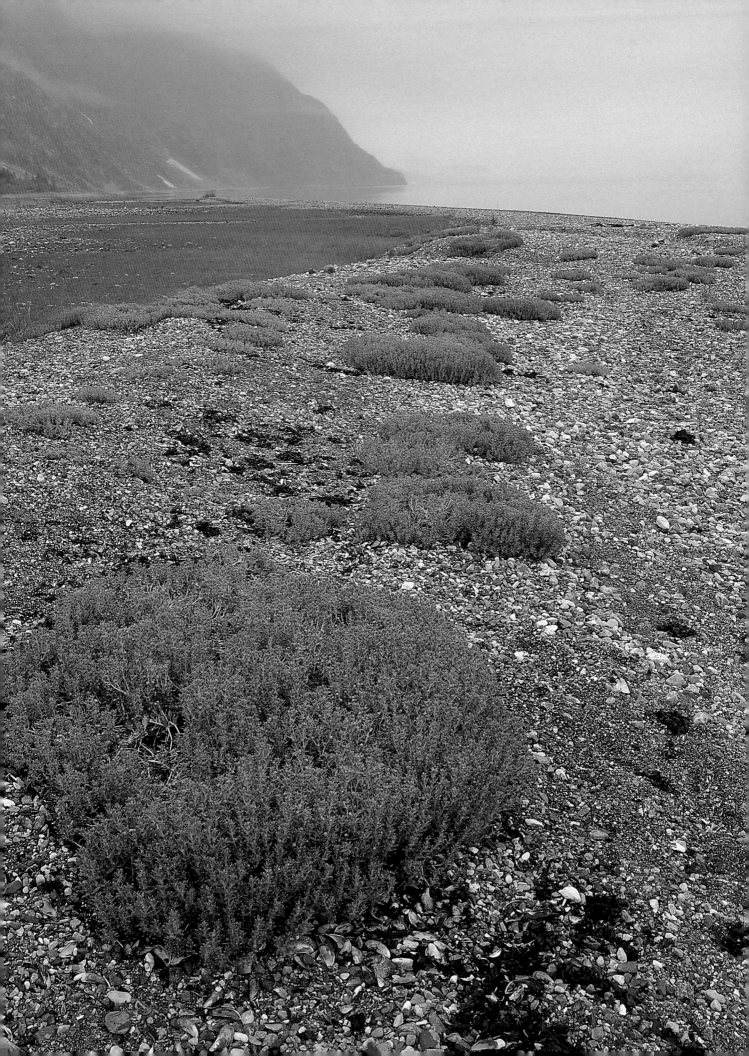

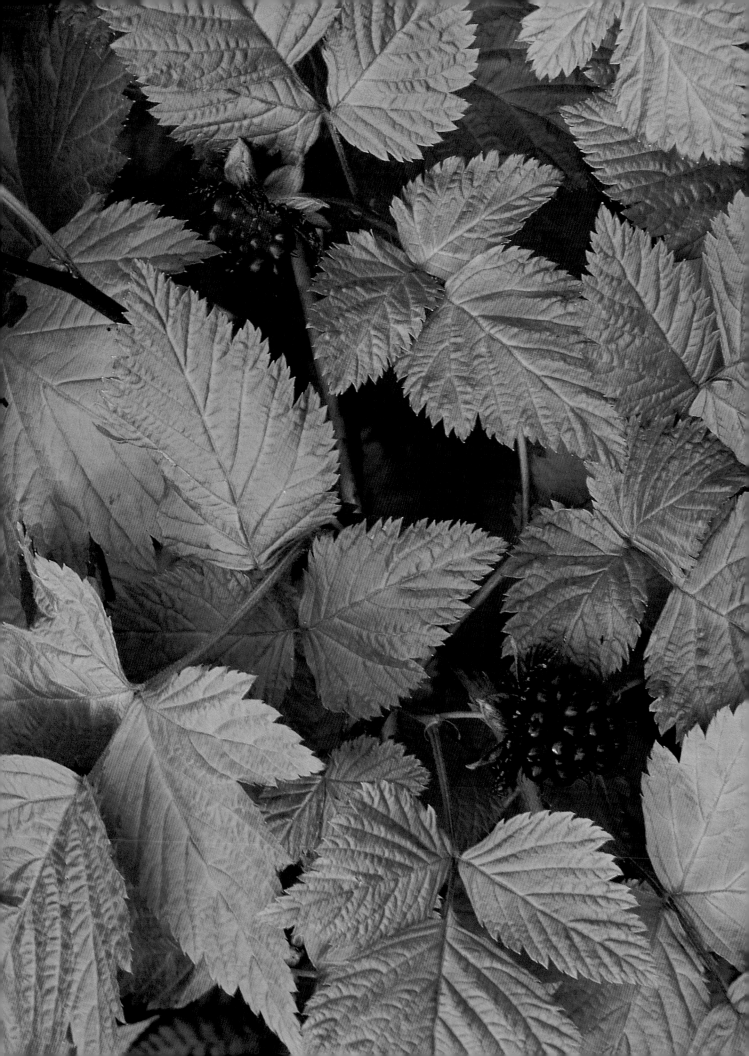

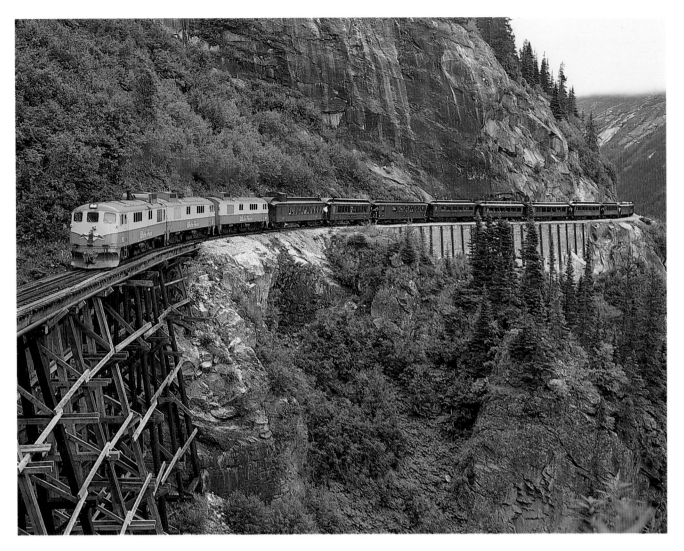

◁ Red salmonberries are a favorite forage of birds and mammals in Southeast Alaska. Unlike other organisms that prefer camouflage over conspicuousness, the beaconlike berries are designed to be eaten and thereby dispersed in the droppings of their consumers. △ The narrow-gauge White Pass and Yukon Route Railroad, a favorite of summer tourists, crosses Tunnel Mountain Trestle en route from Skagway to White Pass, following a route popular with Klondike gold stampeders of the late 1890s.

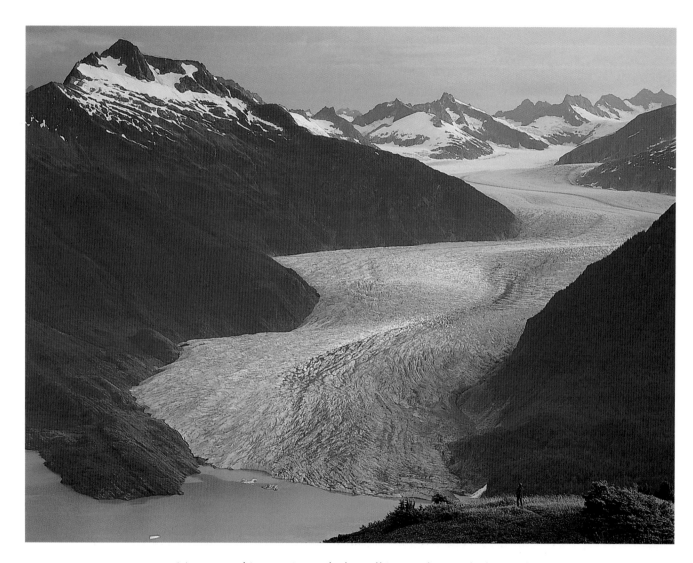

△ It's easy and instructive to feel small in Southeast Alaska, such as during sunrise on Thunder Mountain, above the Mendenhall Glacier. ▷ One of the more than three hundred species of birds that have been documented in Southeast Alaska is the lesser scaup. Like the canvasback and ring-necked duck, the scaup is a heavy-bodied diving duck that requires a running start to enable it to lift off the water. Mallards and teals, by contrast, are dabbling ducks that burst off the water into instant flight.

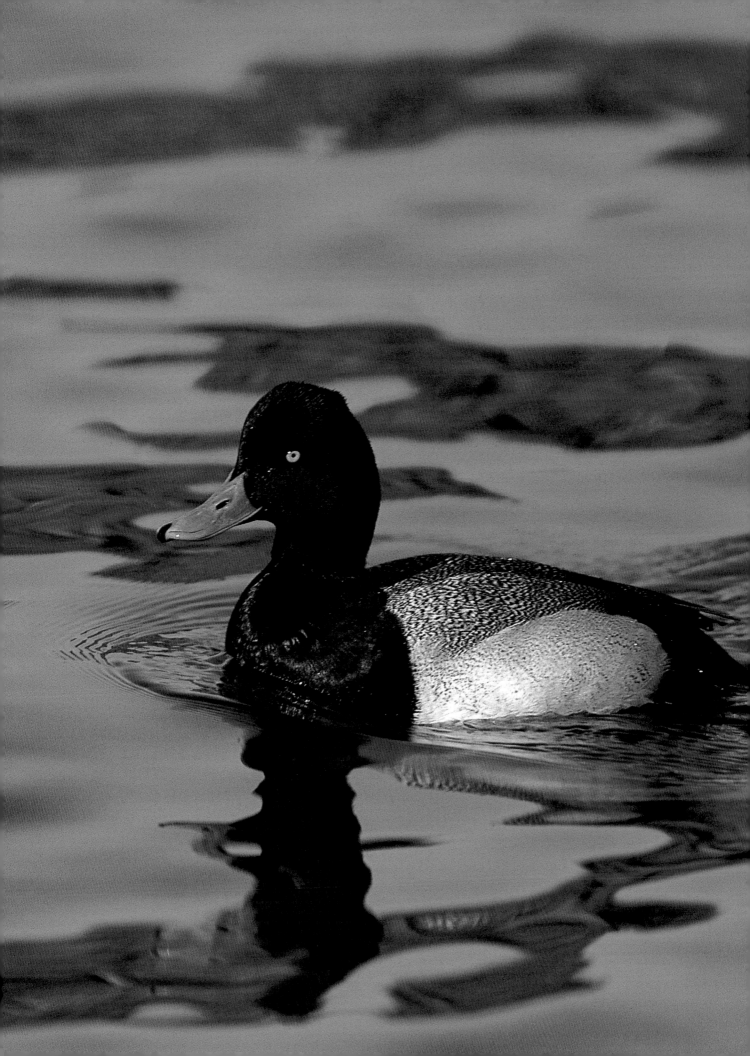

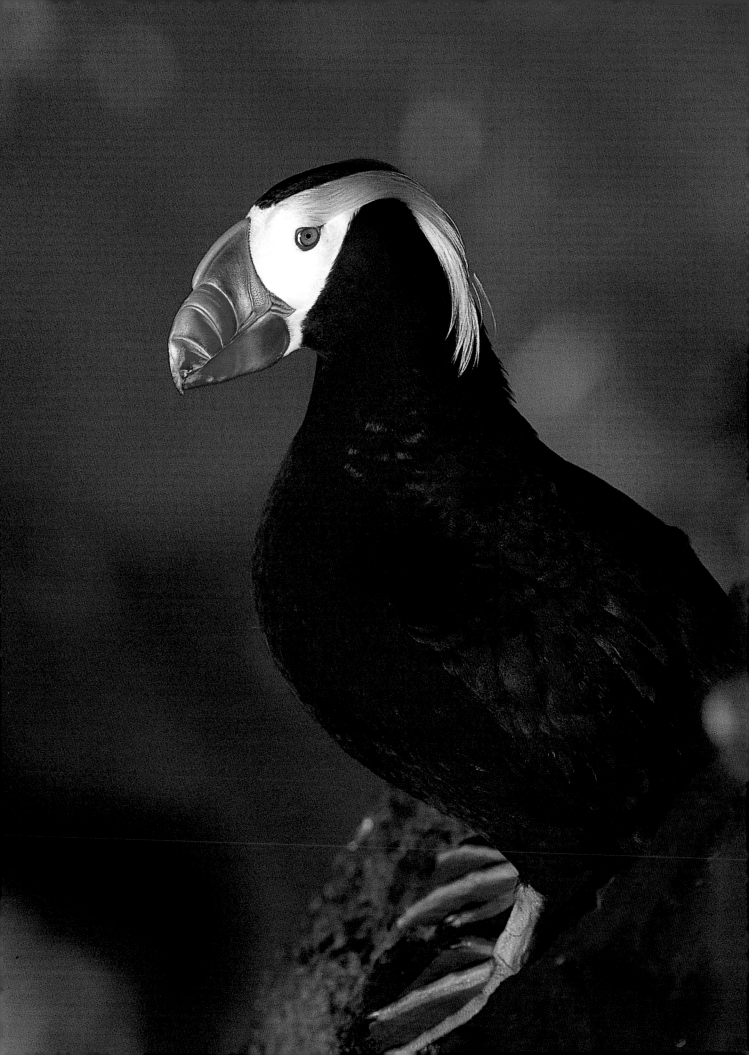

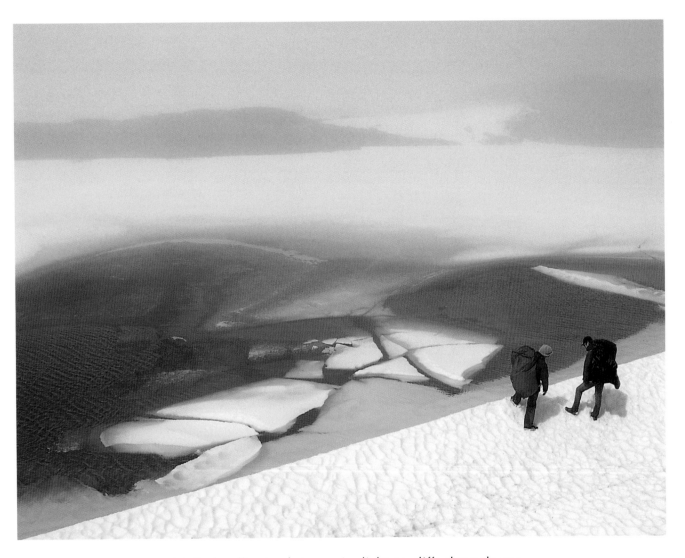

◁ A tufted puffin stands in sunrise light on cliffs above the sea. The puffin's white face and long tufts occur only in summer, when breeding. △ Hikers Larry Bright and Richard Steele pause in the snow and fog near the summit of Chilkoot Pass, on the famous Chilkoot Trail, traversed amid cold adversity by thousands of dreamers bound for the Klondike gold fields in the winter of 1897-98. ▷ A summer sunset over Gastineau Channel welcomes boaters home to Juneau after a day of sport fishing.

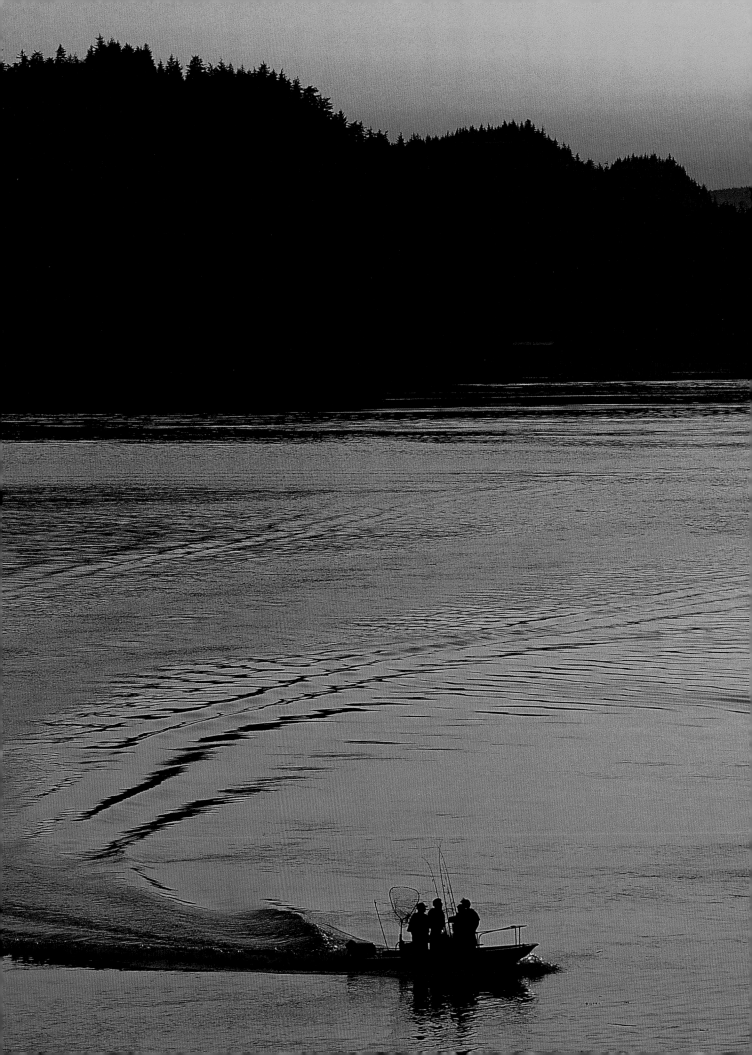

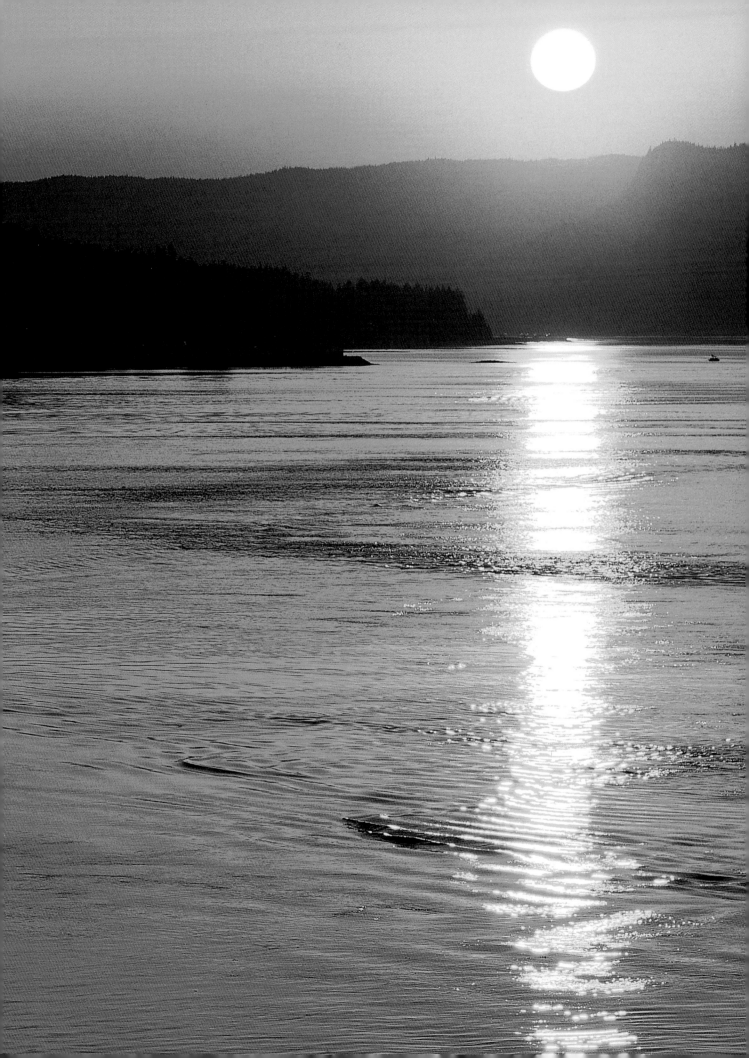

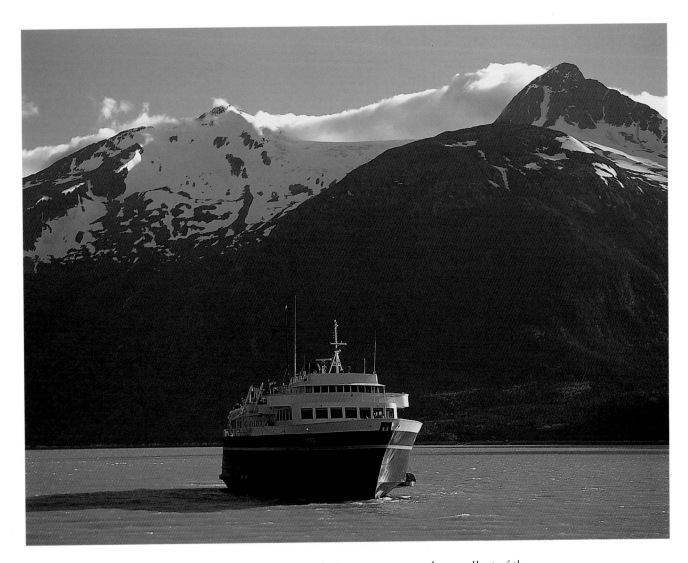

△ The Alaska State Ferry, M/V *Leconte,* among the smallest of the fleet of "Blue Canoes," travels up Chilkoot Inlet from Haines to Skagway. Also known as the Alaska Marine Highway System, the ferries have operated in Southeast Alaska since 1963. ▷ Harbor seals rest on icebergs near South Sawyer Glacier, in Tracy Arm. ▷▷ Boats anchor at the entrance of Mitchell Bay, in Angoon, Admiralty Island's only permanent settlement. Most of the island is a national monument and off-limits to logging.

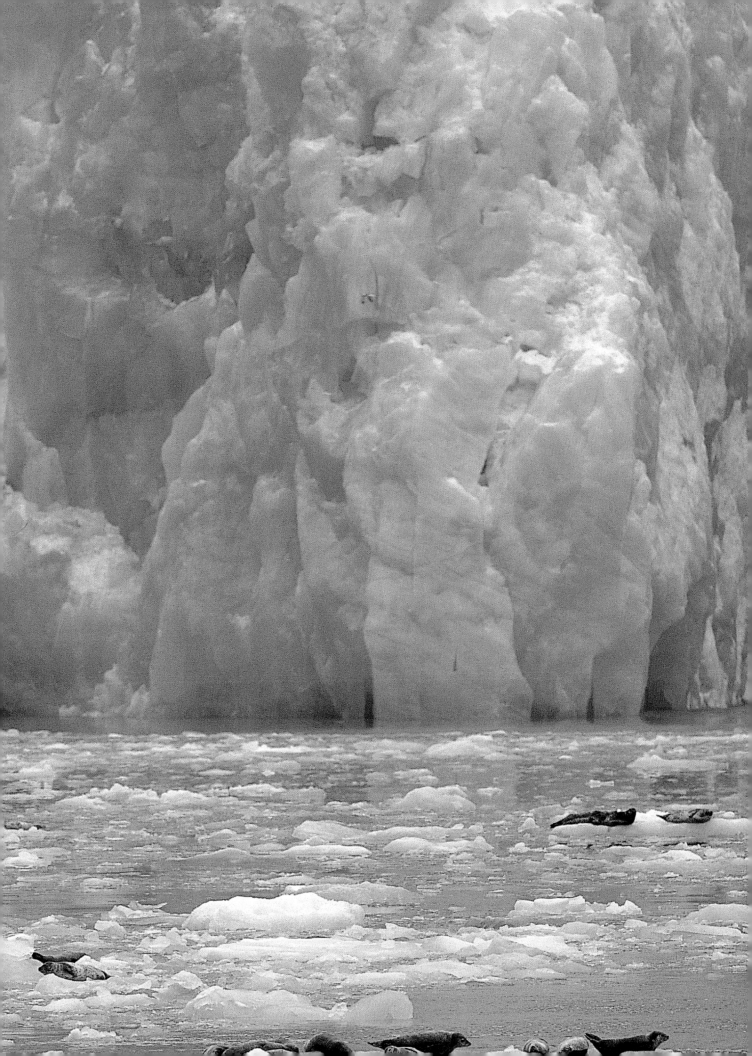

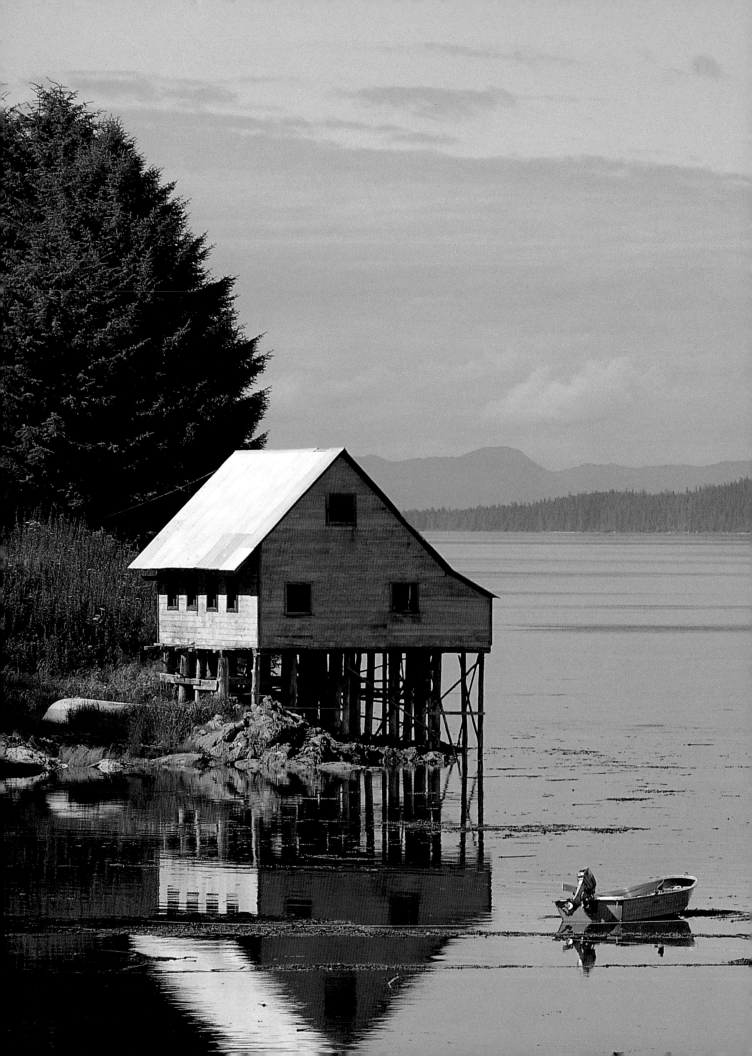

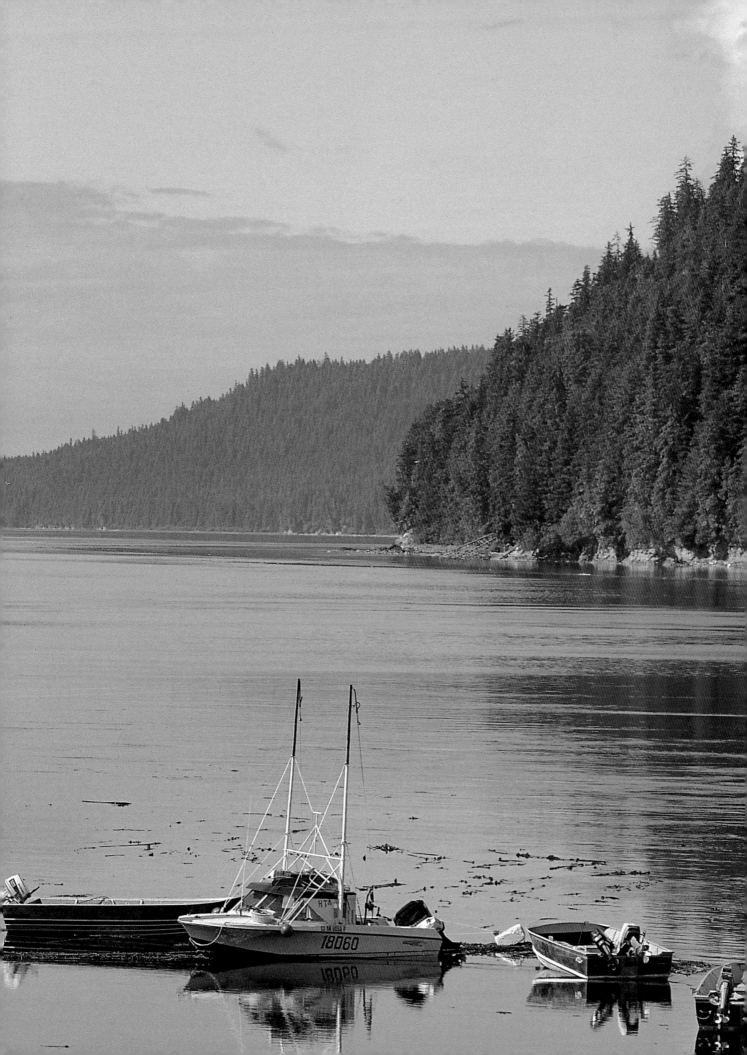

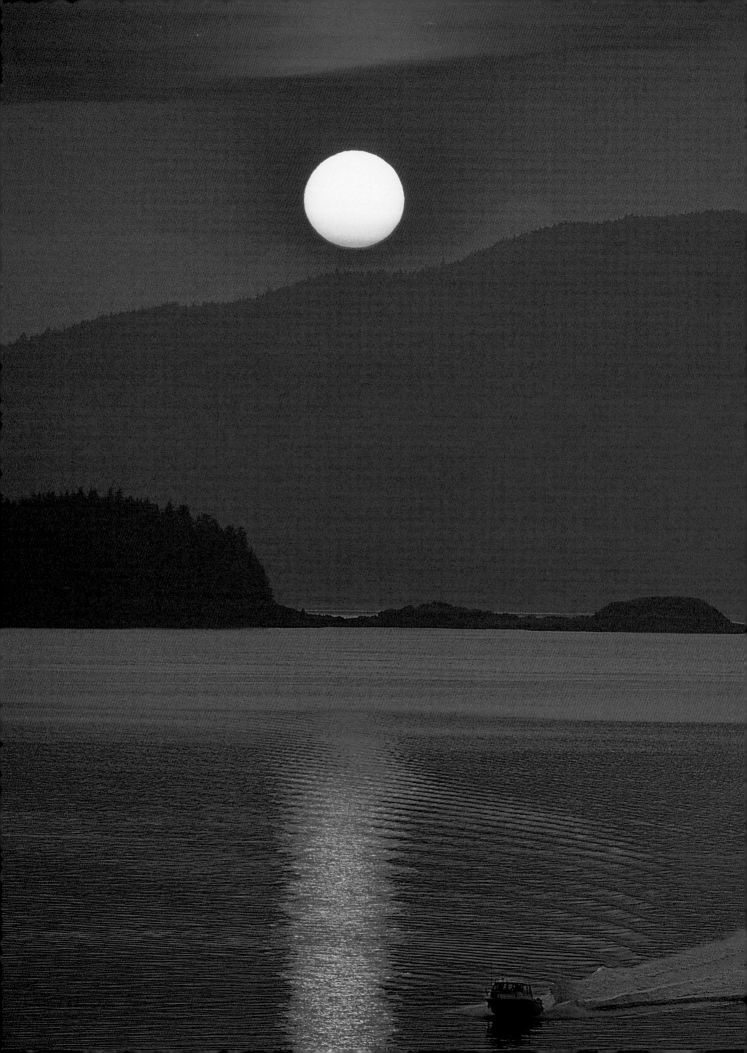

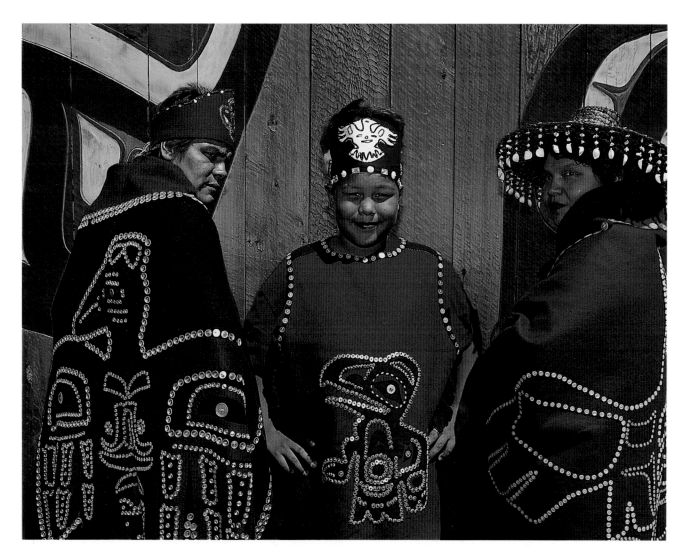

◁ To the north in Canada's Yukon Territory, summer fires create smoky skies and a cinnabar sunset over Lynn Canal. △ Tlingit dancers Albert Jackson, Timothy Williams, and Lorraine Williams pause outside a clan house after a performance in Saxman, near Ketchikan. Through legends and dance and the creation of blankets, baskets, totem poles, and other crafts, Alaska Natives strive to keep alive traditional values, which can suffer amid corporate mindsets and modern temptations.

63

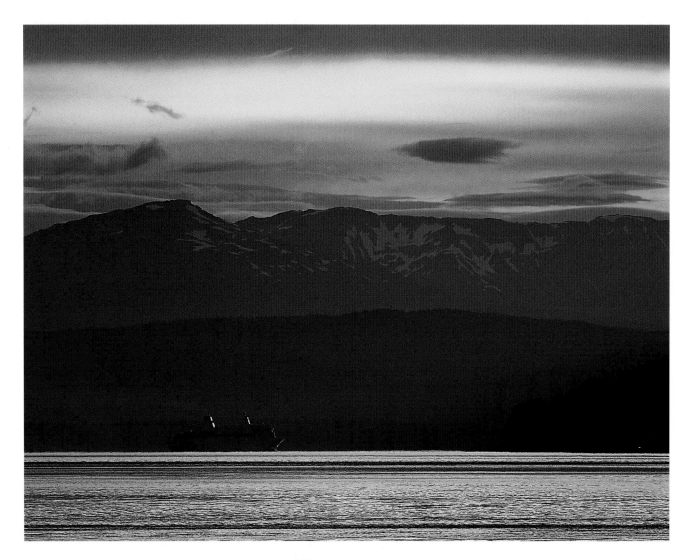

△ An amber sunset highlights a cruise ship in Stephens Passage off the south end of Douglas Island. Cruising Alaska's Inside Passage has grown in popularity since the 1880s, when steamships first arrived and intrepid women in Victorian dresses climbed ladders onto the glaciers. Modern ships today offer more luxury than daring, yet a cruise to Alaska can still be an adventure, a dream come true. ▷ In late summer, a cow moose raises her head from feeding on aquatic vegetation in a pond.

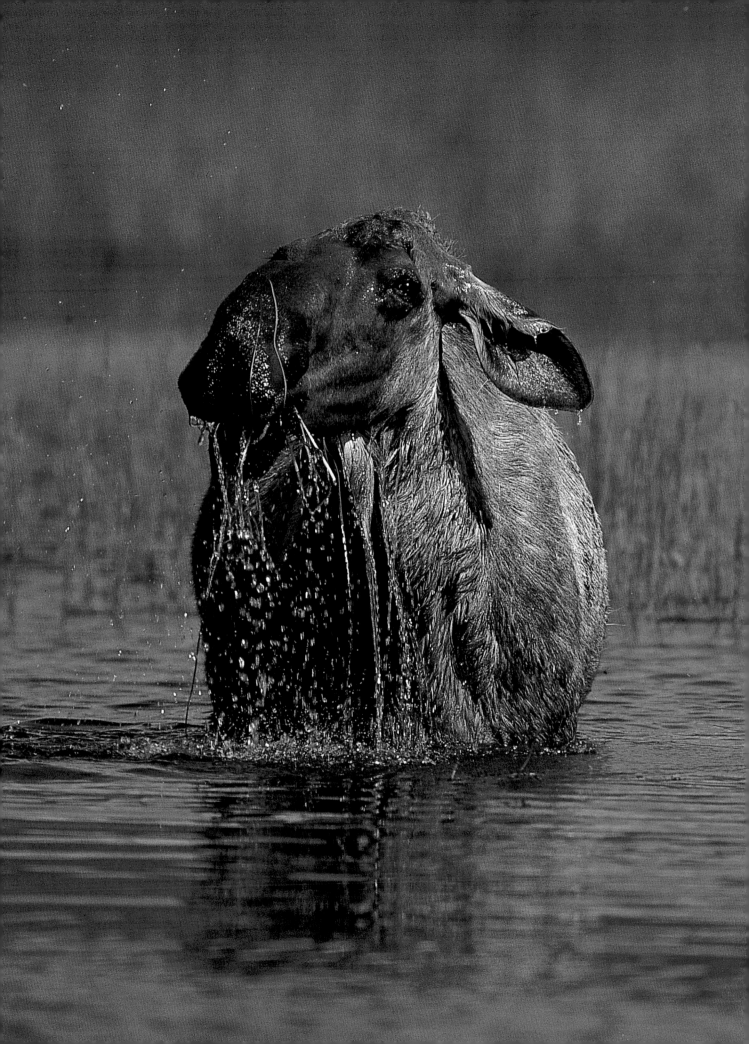

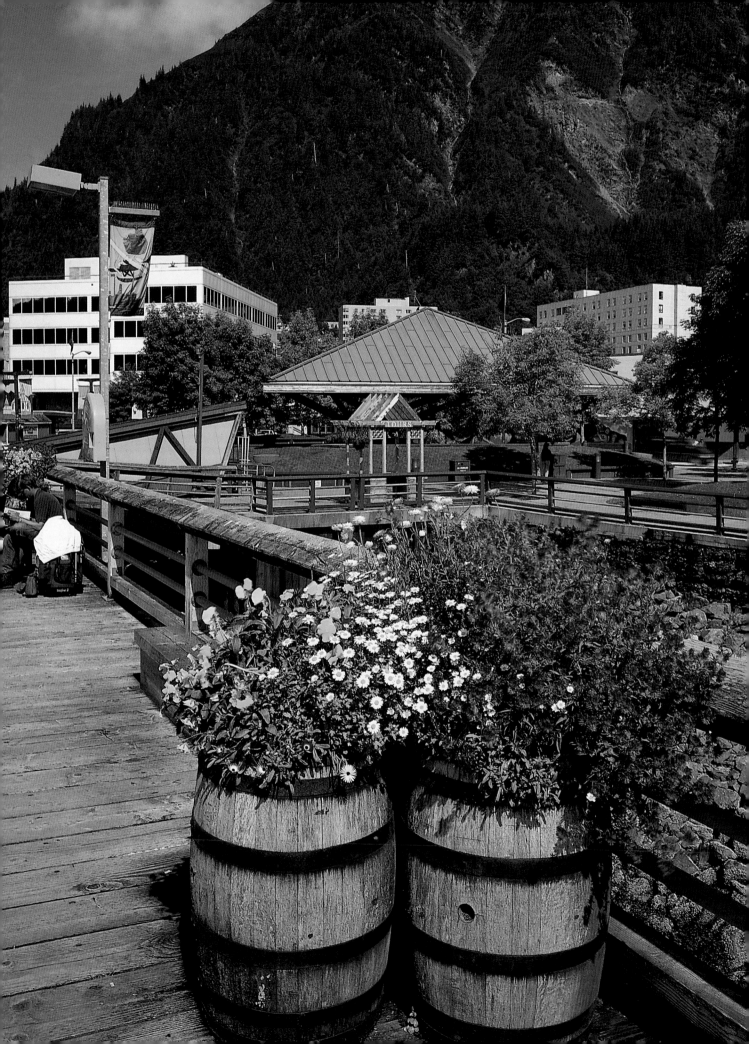

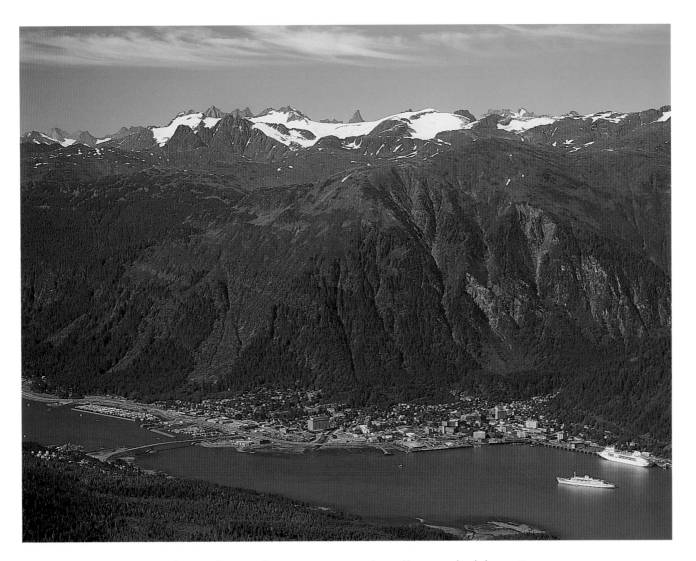

◁ Juneau's waterfront on a sunny day offers a colorful respite from the rain common in Southeast Alaska. Though born from mining, the capital city now survives primarily on government and summer tourism. △ Seen from atop Douglas Island, Juneau lies comfortably along Gastineau Channel. Beyond rise the Coast Mountains that cradle the Juneau Icefield, birthplace of glaciers. Ten thousand years ago, during the Ice Age, nearly every contour in this photo was beneath glacial ice.

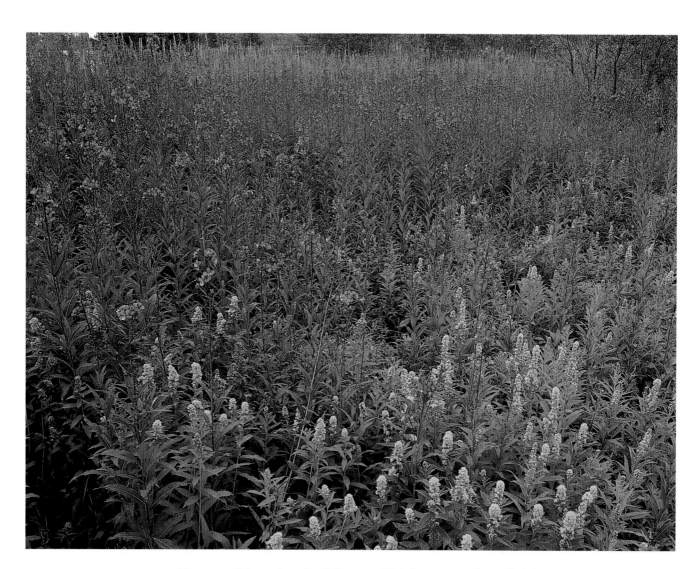

△ Elegant goldenrod and tall fireweed brighten a predawn field in Gustavus. Because stalks of fireweed bloom from the bottom up, summer is said to be over when the last, topmost blossom fades and falls, and the fireweed goes to seed. ▷ A 4:00 A.M. sunrise paints the sky crimson above Point Gustavus, looking north toward Beartrack Mountain. At 58° north latitude, the sun is up for eighteen hours in summer, but only six in winter.

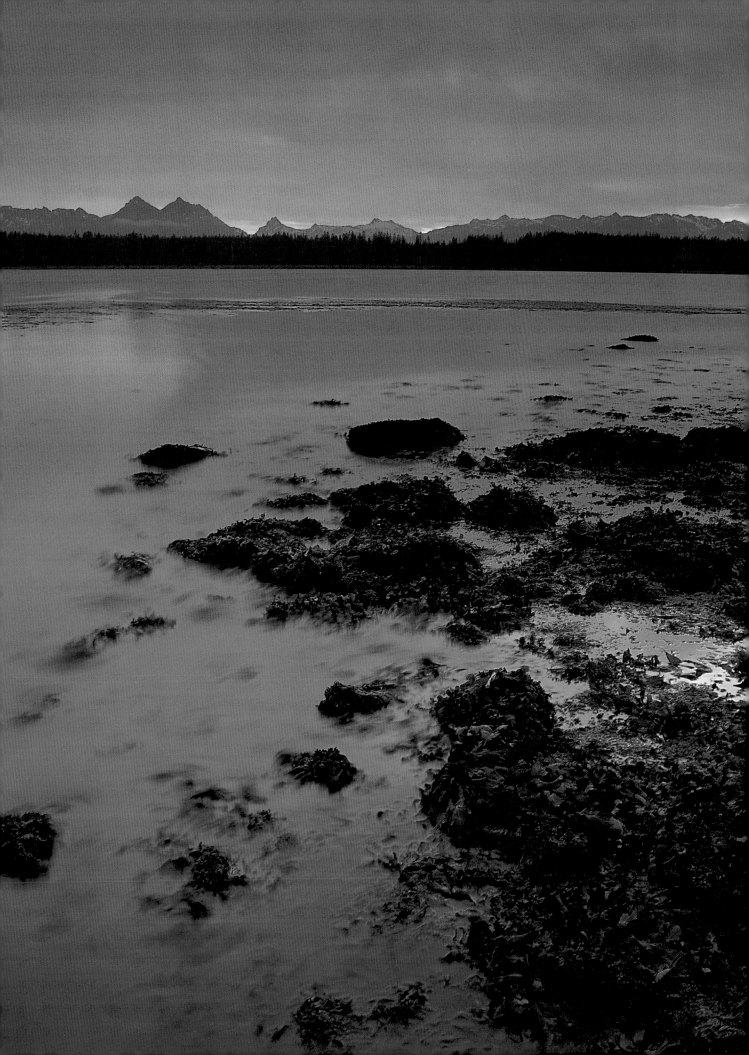

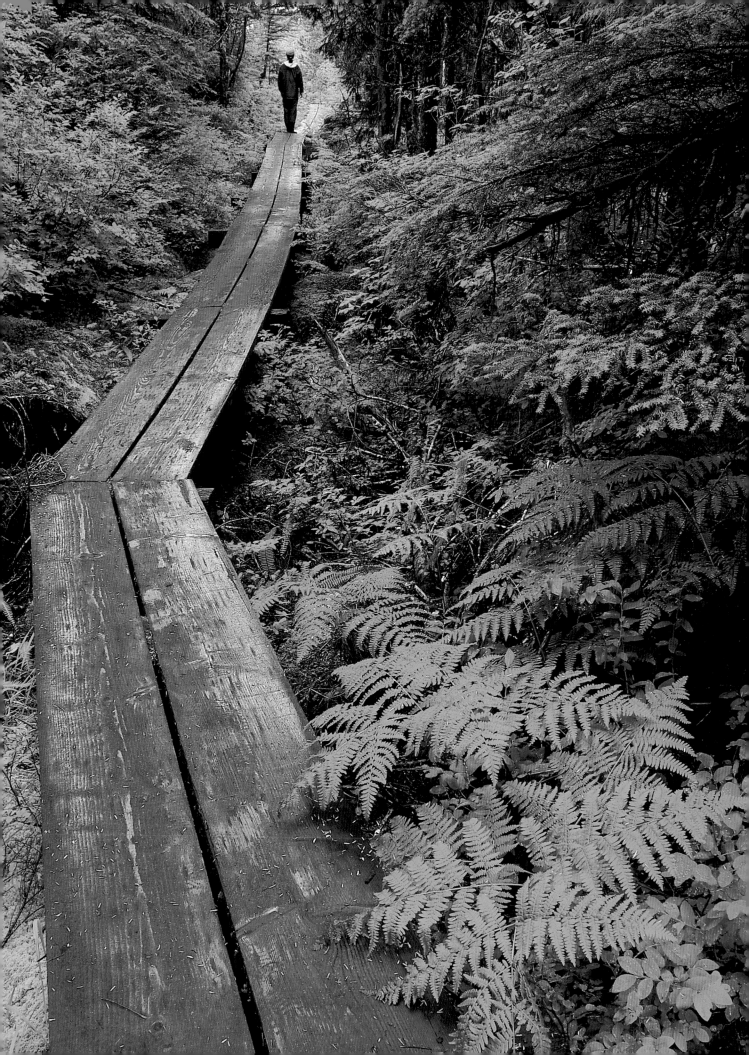

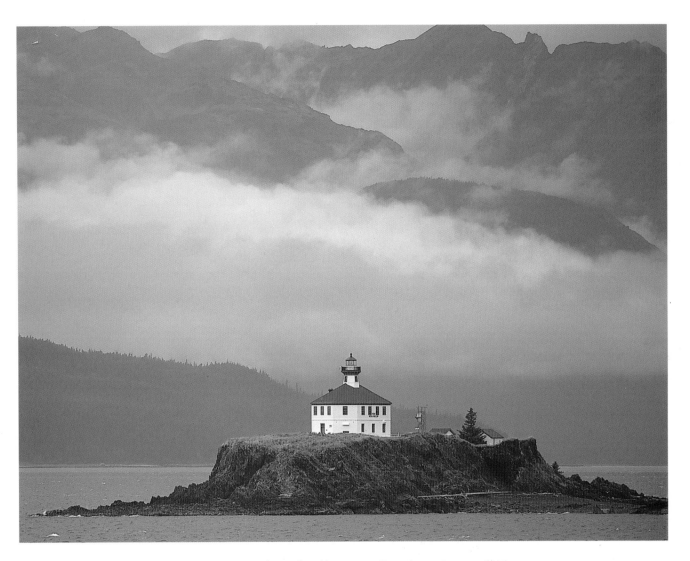

◁ A quiet, rustic boardwalk, extending from Baranof Warm Springs to Baranof Lake, invites people into the forest. △ The Eldred Rock Lighthouse, first lighted in 1906, stands a lonely watch in the middle of Lynn Canal, between Juneau and Haines, backdropped by the rugged Chilkat Range. ▷ Icebergs calved from South Sawyer Glacier drift in Tracy Arm. Like many tidewater glaciers in Southeast Alaska today, South Sawyer retreats as its terminus calves ice faster than the glacier flows forward.

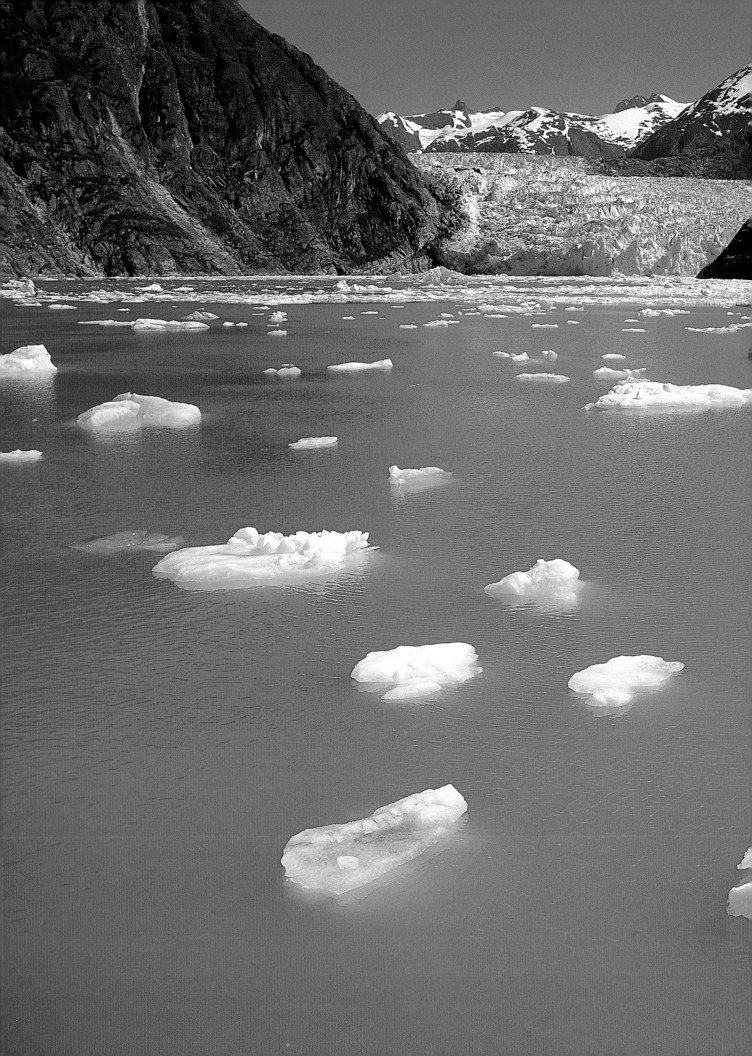

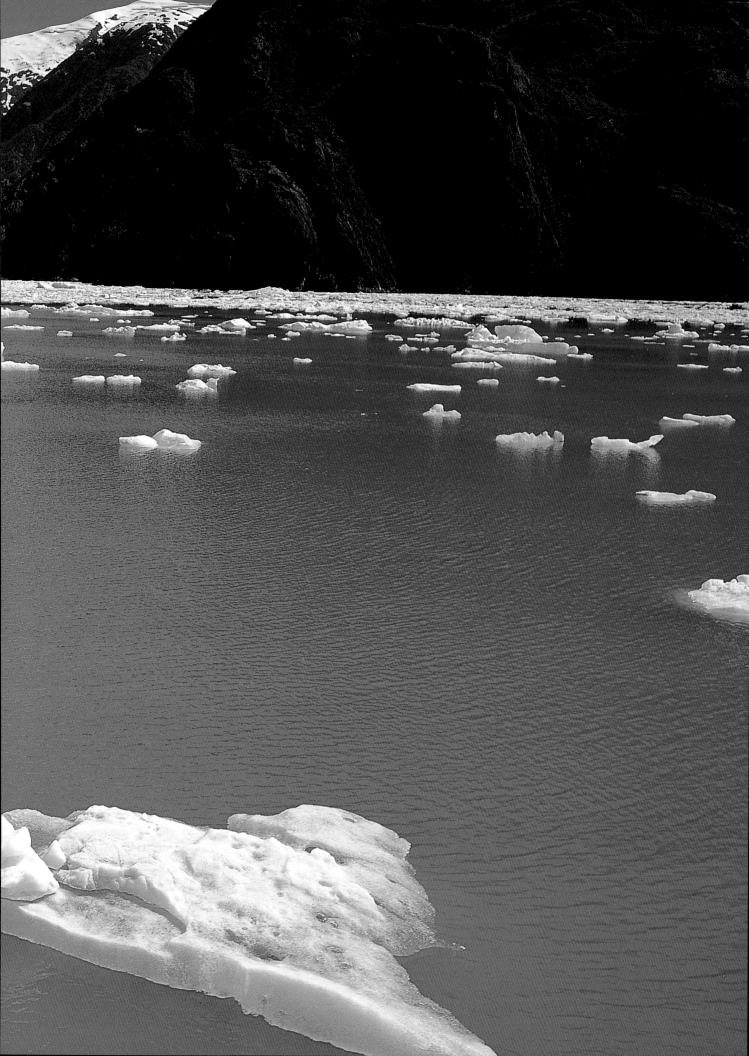

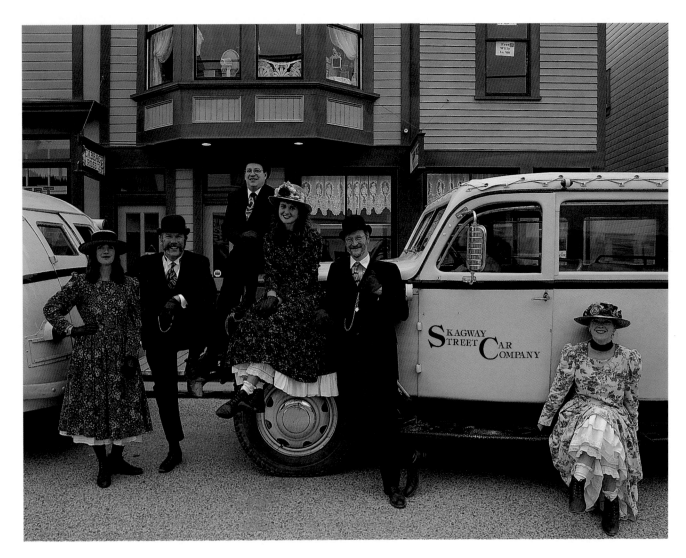

△ Dressed in their 1890s finery, drivers with the Skagway Street Car Company pose on downtown Skagway's Broadway Street, part of Klondike Goldrush National Historical Park. ▷ Give a glacier enough time and it will move mountains, as evidenced on the surface of Grand Canyon Glacier, near Skagway, where sediment and boulders of all sizes are excavated and carried downslope. ▷▷ Starfish cluster on shore near Sitka, where twice each day tides rise and fall as much as twelve feet.

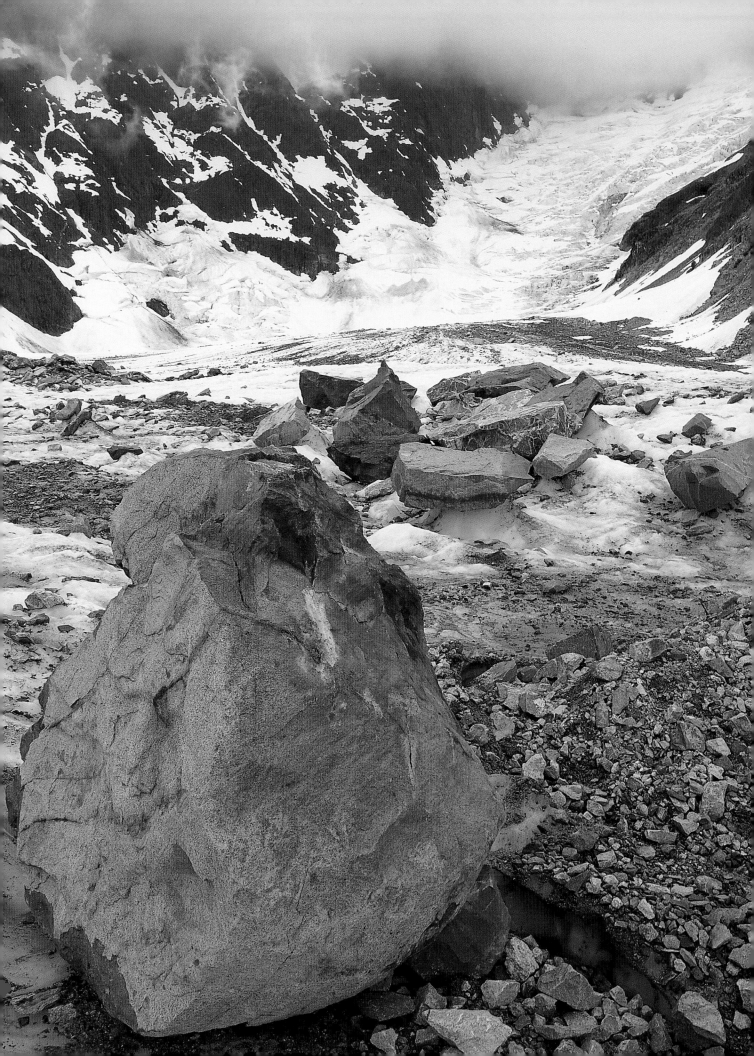

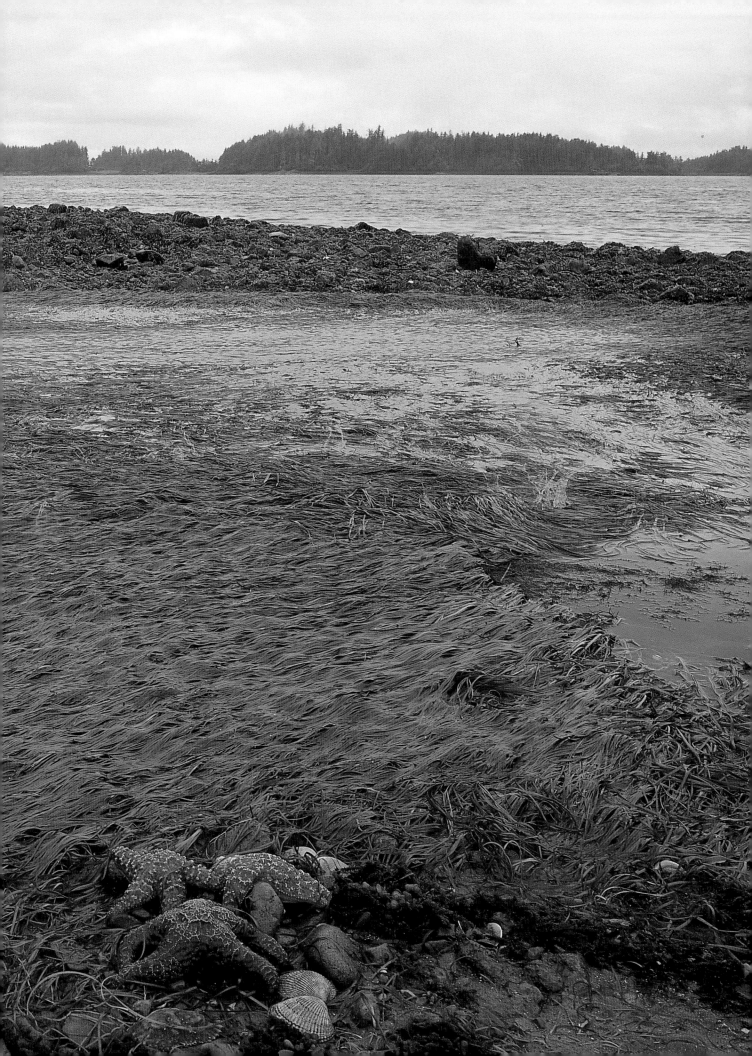

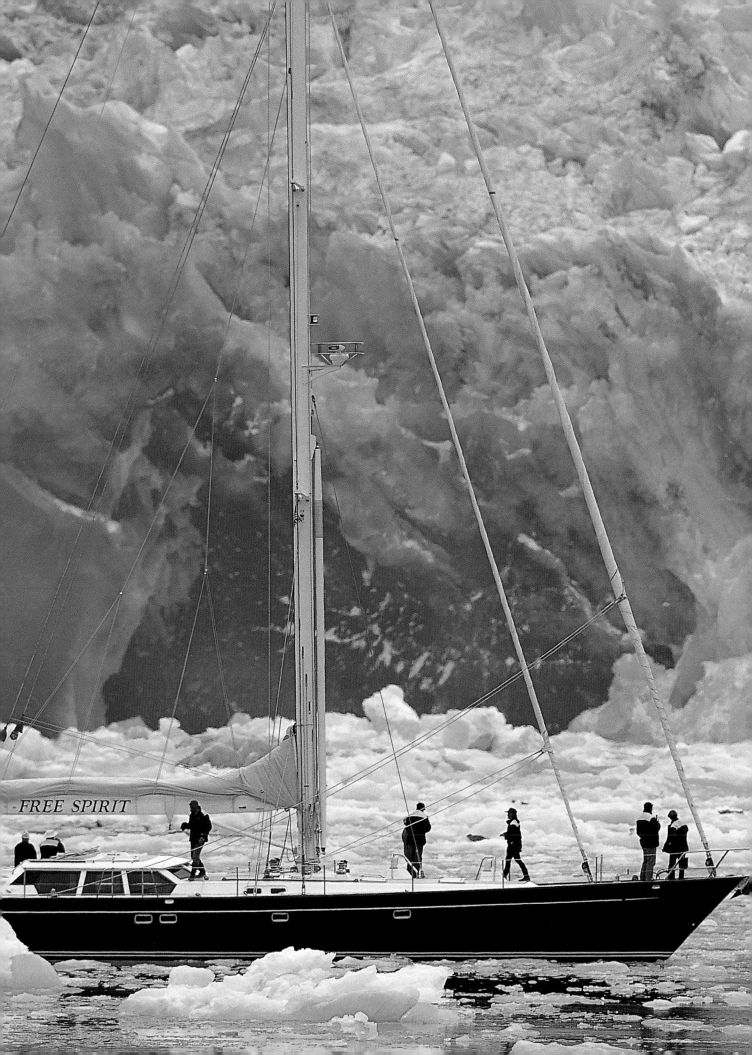

FREE SPIRIT

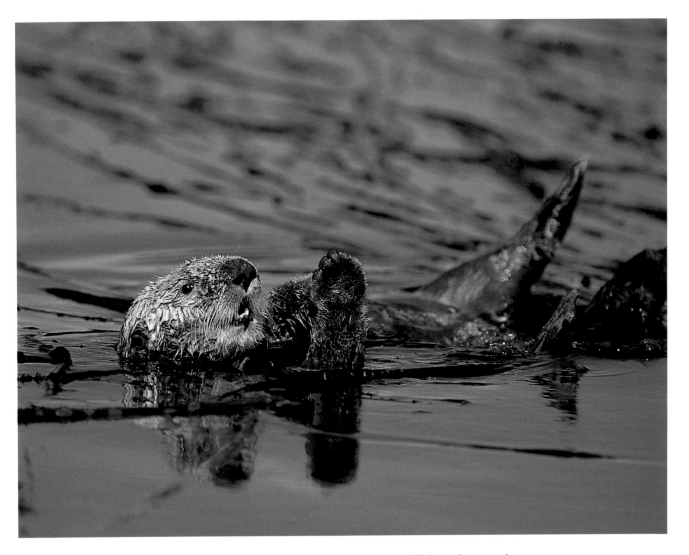

◁ With all hands on deck, a sailboat idles off the tidewater face of Tracy Arm's South Sawyer Glacier. As light hits dense glacial ice such as this, all colors of the visible spectrum are absorbed except blue, which is scattered and refracted. △ Back from the brink of extinction, a sea otter floats amid a bed of kelp. Once overhunted for their furs, sea otters today have made a come-back—with the assistance of wildlife biologists—and occupy a large percentage of their former coastal habitat. With knowl-edge and compassion, mankind is learning that places like Alaska's Inside Passage can remain wild and pristine.

Acknowledgments

For their hospitality and friendship: a lifesaver shower, a night on a sofa, a spare bed, a plate of spaghetti, a cup of tea, a clever witticism (what other kind is there?), a good laugh, a long soak in a hot tub (strictly medicinal), thanks to Patty Brown in Haines; Jim and Judy Hauck in Juneau; Geoff and Marcy Larson in Juneau; Dick and Judi Rice in Juneau; Luann McVey, Richard, Lydia, and Laura Steele in Douglas; George and Lynne Jensen in Gustavus; Hank Lentfer in Gustavus; Dave, Kris, and Kelly Ann Nemeth in Gustavus; Lewis and Ellie Sharman in Gustavus; Bruce and Sharon Paige in Gustavus; Jane Eidler, Mike, Logan, Lauren, and Lincoln Wild in Sitka.

To the following Southeast Alaska artists and photographers who have inspired me with their work and warmed me with their friendship, thank you: Hall Anderson, Donna Catotti, Laurie Ferguson Craig, Jeff Gnass, Rob Goldberg, John Hyde, Charles Jimmie, Sr., David Job, Mark Kelley, Chip Porter, Ray Troll, and Evon Zerbetz.

To the dedicated staff of Glacier Bay National Park and Preserve goes my appreciation for their commitment to protect the beauty of a very special place.

And to Melanie Heacox, my best friend, thanks again for your invaluable love and support.

Thanks also to the capable pilots who got me "up there" and back safely: Ken Tyler at Haines Airways, Steve Wilson and Chuck Schroth at Air Excursions, Buddy Ferguson at Ward Air, and the many skilled pilots at Temsco Helicopters. And to Lynn Schooler, master mariner at Wilderness Swift Adventures, fair winds friend. Keep up the good fight.

Last and most important, for their stamina, vision, and selfless courage to speak on behalf of the wild places, thanks to the staff and members of SEACC—the Southeast Alaska Conservation Council.

KIM HEACOX